In memory of my beloved husband

once upon a time...

Kata Legrady Graphic Works

SKIRA

Edited by
David Rosenberg

Art director
Marcello Francone

Design
Luigi Fiore

Editorial coordination
Vincenza Russo

Copy editor
Emanuela Di Lallo

Translation
Paul Metcalfe on behalf
of *Scriptum*, Rome

Layout
Fayçal Zaouali

Image editing
Artnetworx, Hannover

First published in Italy in 2014 by
Skira Editore S.p.A.
Palazzo Casati Stampa
via Torino 61
20123 Milano
Italy
www.skira.net

© 2014 Kata Legrady
© 2014 David Rosenberg for his text
© 2014 Skira editore, Milan

Printed and bound in Italy.
First edition

ISBN: 978-88-572-1964-6

Distributed in USA, Canada, Central
& South America by Rizzoli
International Publications, Inc., 300
Park Avenue South, New York, NY
10010, USA. Distributed elsewhere
in the world by Thames and Hudson
Ltd., 181A High Holborn, London
WC1V 7QX, United Kingdom.

Contents

Kata Legrady: Drawings

Appendix

MASKS & GUNS

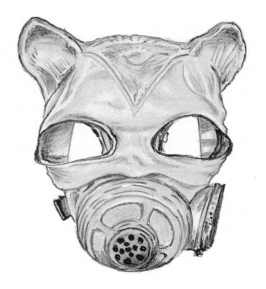

Catwoman (pink), 2013
Coloured pencil and pencil on paper
21 x 14.7 cm

Catwoman (blue), 2013
Coloured pencil and pencil on paper
21 x 14.7 cm

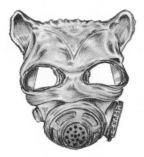

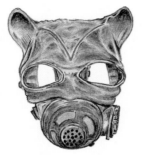

Catwoman "US Dollar" (green),
2013
Coloured pencil and pencil on paper
21 x 14.7 cm

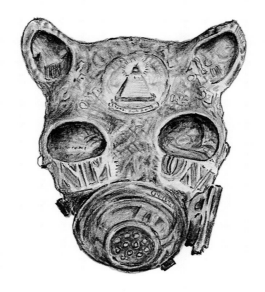

Government "Saddle" (blue I), 2013
Coloured pencil and pencil on paper
21 x 14.7 cm

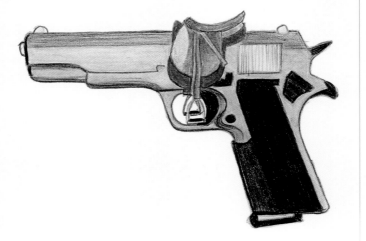

Government "Saddle" (blue II),
2013
Coloured pencil and pencil on paper
21 x 14.7 cm

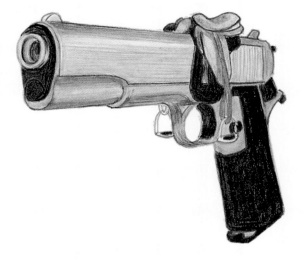

Government "Saddle" (white II),
2013
Coloured pencil and pencil on paper
21 x 14.7 cm

Government "Saddle" (white I),
2013
Coloured pencil and pencil on paper
21 x 14.7 cm

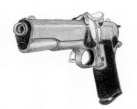

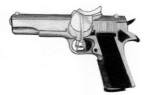

Government "Saddle" (pink II),
2013
Coloured pencil and pencil on paper
21 x 14.7 cm

Government "Saddle" (pink I), 2013
Coloured pencil and pencil on paper
21 x 14.7 cm

Government "Saddle" (yellow II),
2013
Coloured pencil and pencil on paper
21 x 14.7 cm

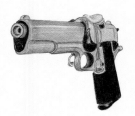

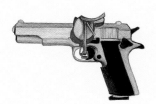

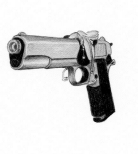

Government "Saddle" (yellow I),
2013
Coloured pencil and pencil on paper
21 x 14.7 cm

Government "Saddle" (brown II),
2013
Coloured pencil and pencil on paper
21 x 14.7 cm

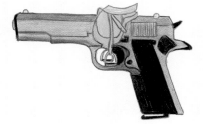

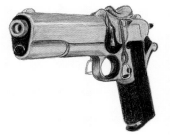

Government "Saddle" (brown I),
2013
Coloured pencil and pencil on paper
21 x 14.7 cm

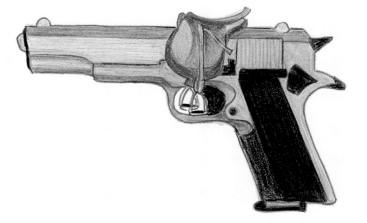

STRANGE FRUITS

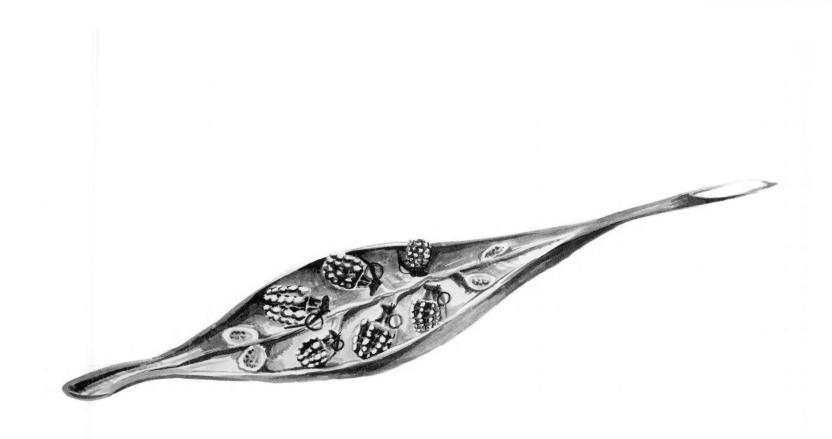

Pea Pod, 2011
Ink on paper
29.7 x 42 cm

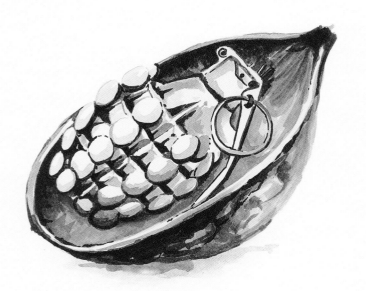
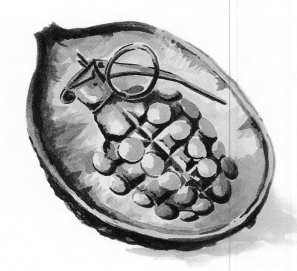

Nut, 2011
Ink on paper
29.7 x 42 cm

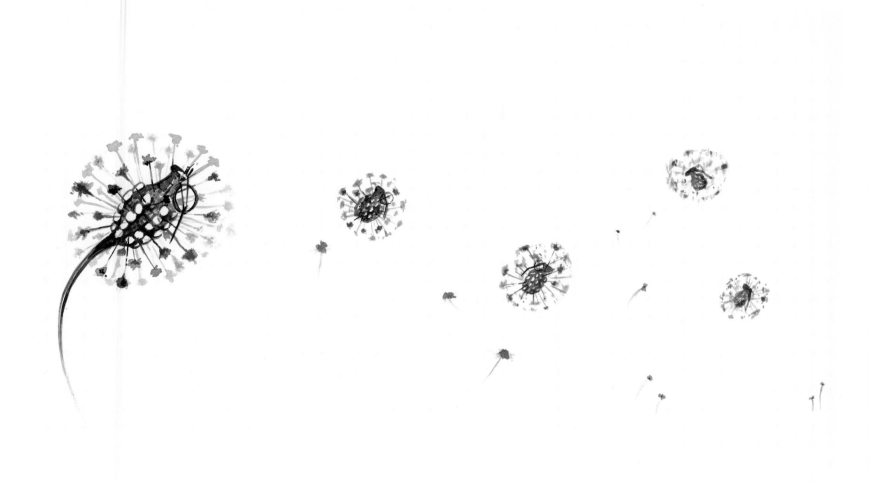

Dandelion, 2011
Ink on paper
29.7 x 42 cm

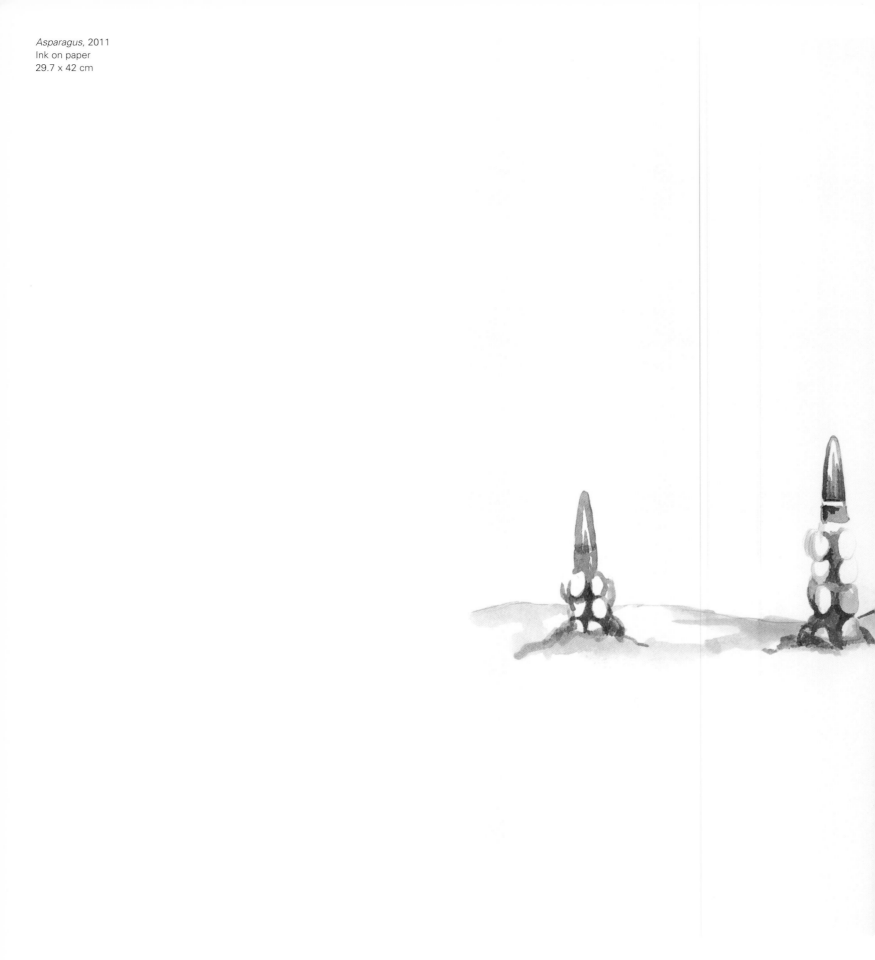

Asparagus, 2011
Ink on paper
29.7 x 42 cm

24

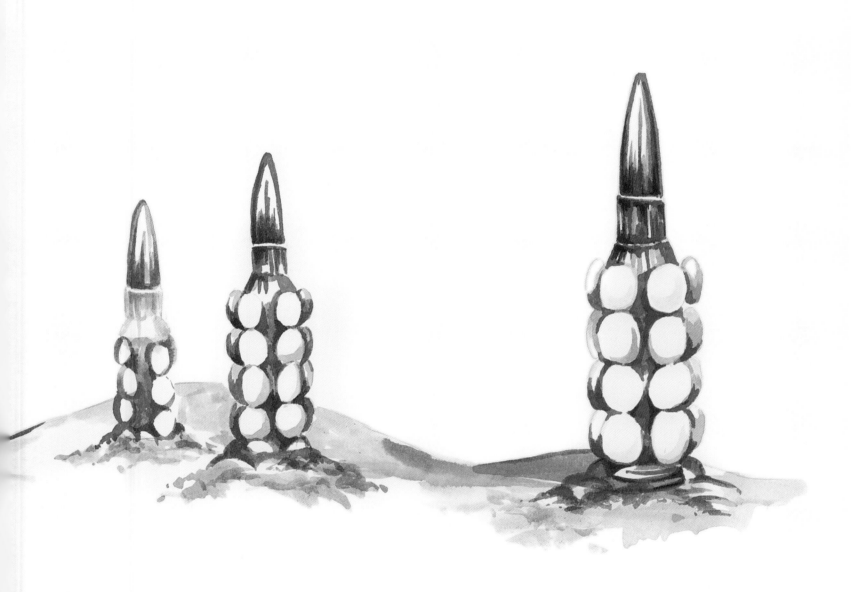

SWEET WEAPONS

Child Soldier & Kalashnikov, 2007
Colour print and pencil on paper
58.2 x 45 cm (framed)

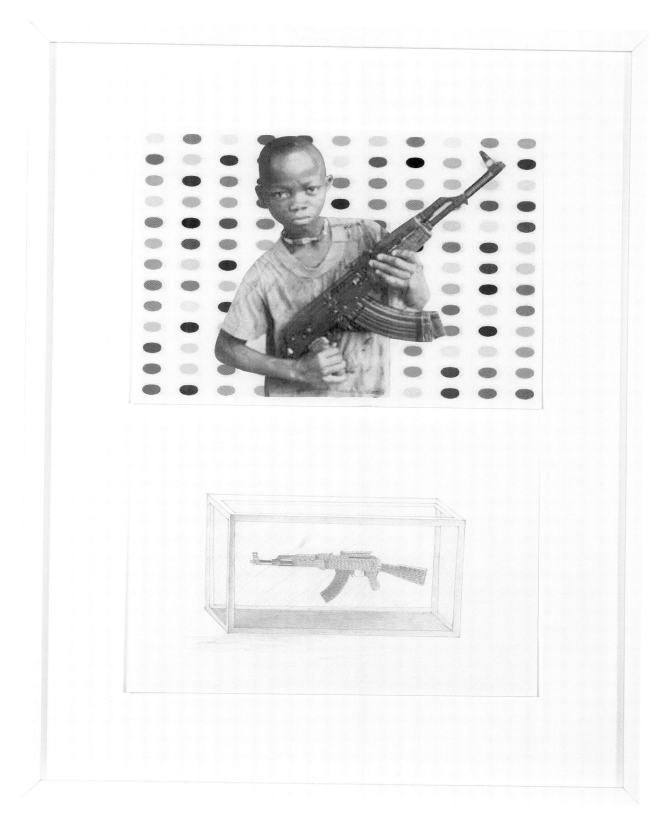

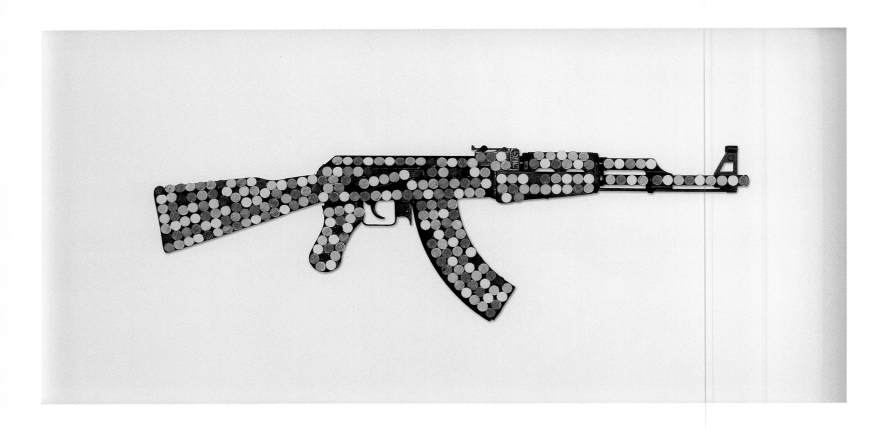

Kalashnikov (multicolor), 2007
Felt pen on photograph
30 x 61.2 cm

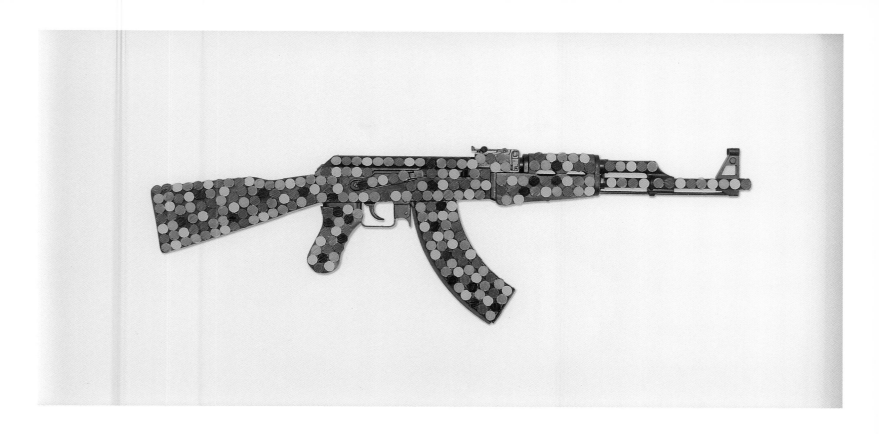

Kalashnikov (multicolor), 2007
Felt pen on photograph
30 x 61.2 cm

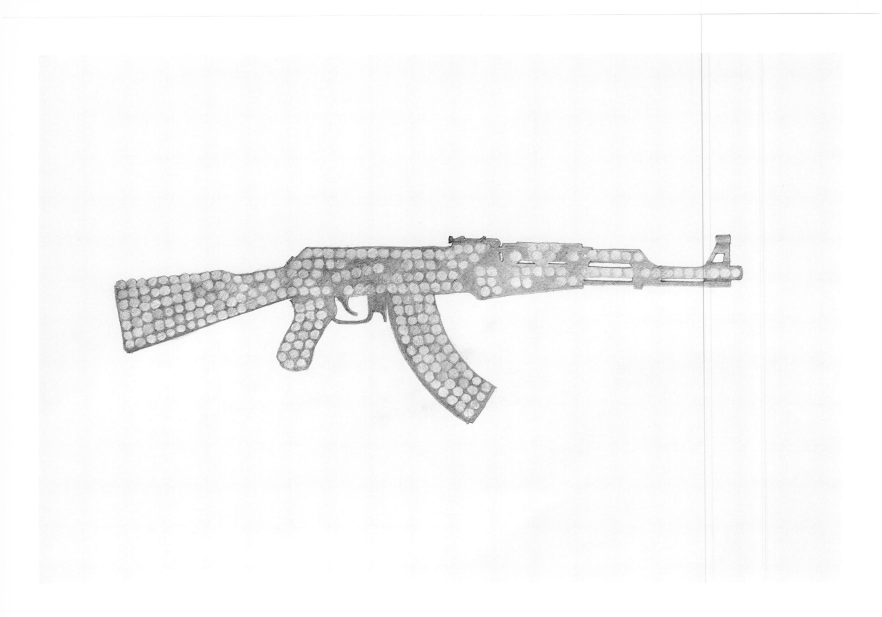

Kalashnikov, 2007
Pencil on paper
21 x 29.5 cm

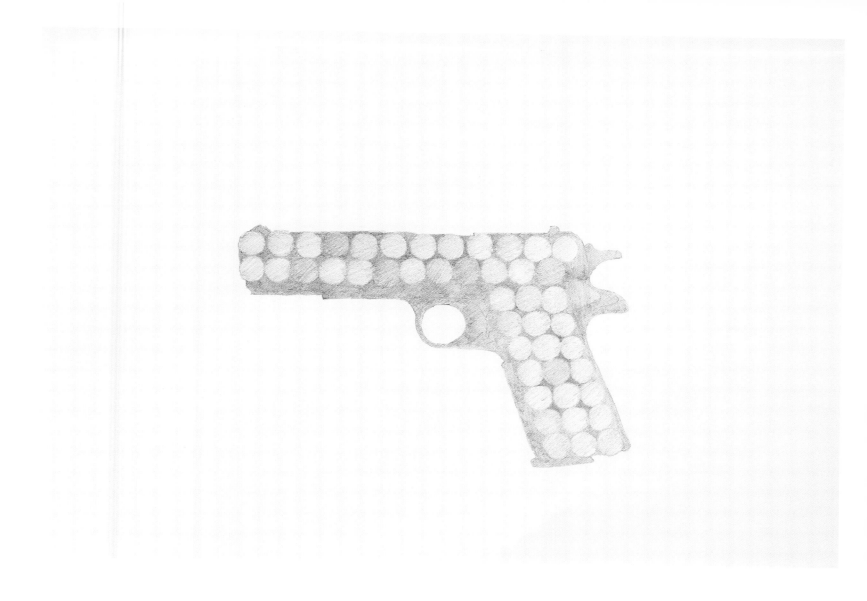

Government, 2007
Pencil on paper
21 x 29.5 cm

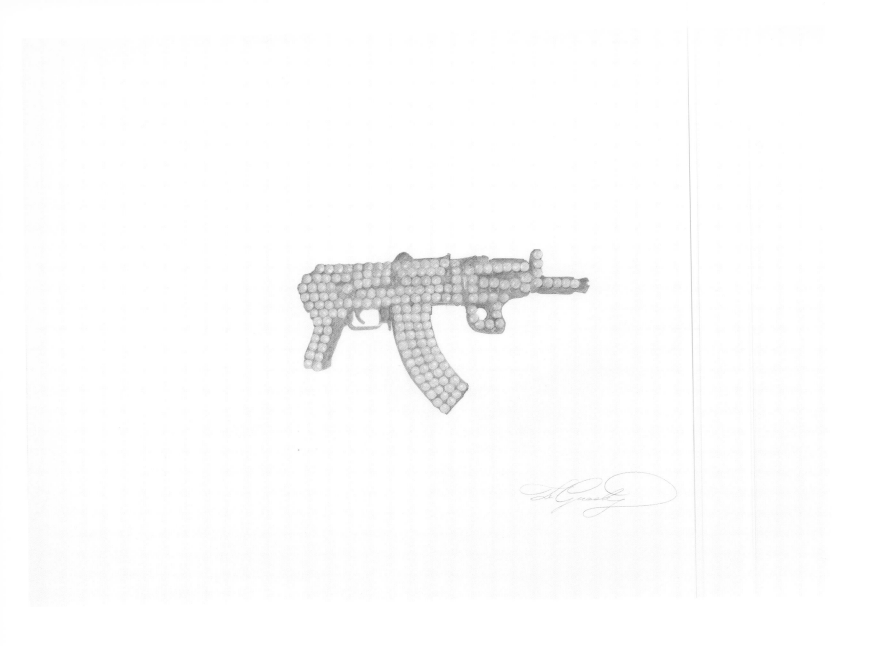

Machine Gun, 2007
Pencil on paper
57.5 x 77 cm

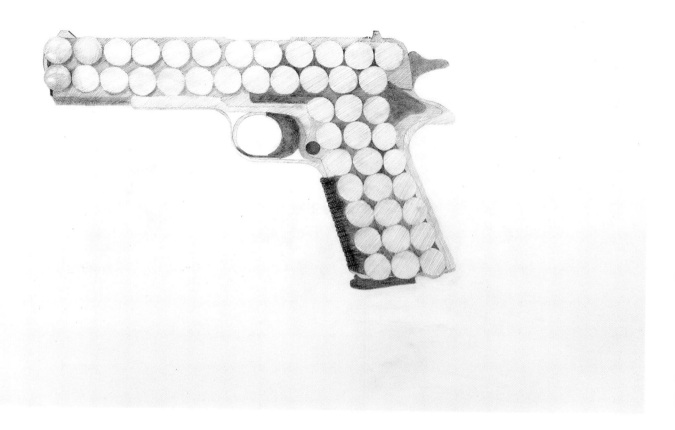

Government, 2007
Pencil on paper
57.2 x 77 cm

Kalashnikov & Long Pistol, 2007
Pencil on paper
48 x 34.8 cm (framed)

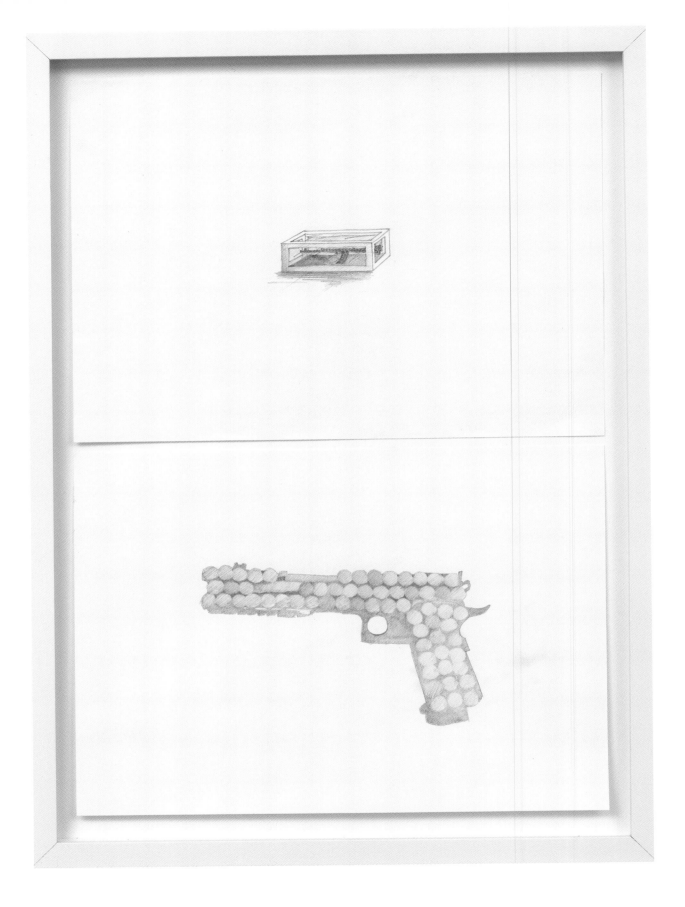

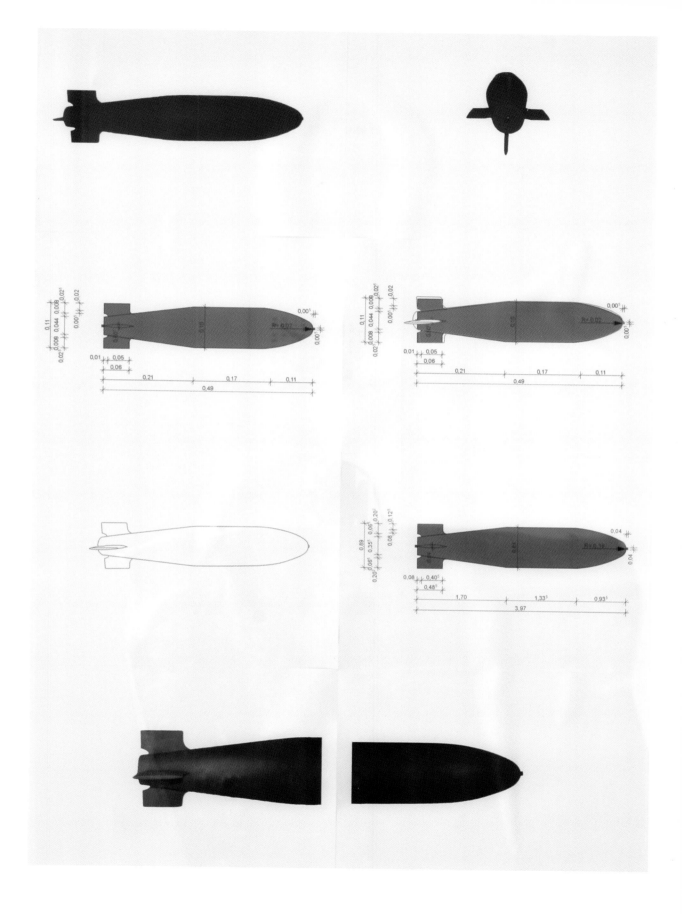

39

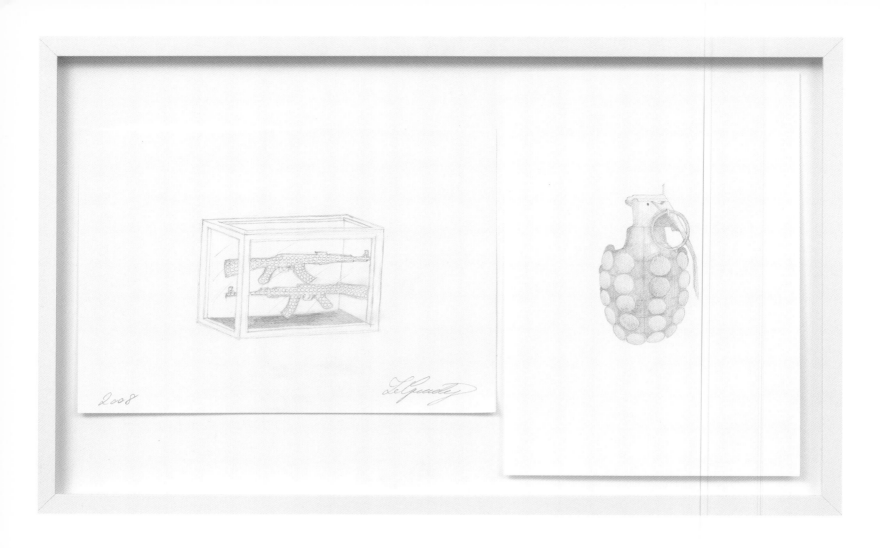

Kalashnikovs & Pineapple, 2008
Pencil on paper
35.1 x 57.2 cm (framed)

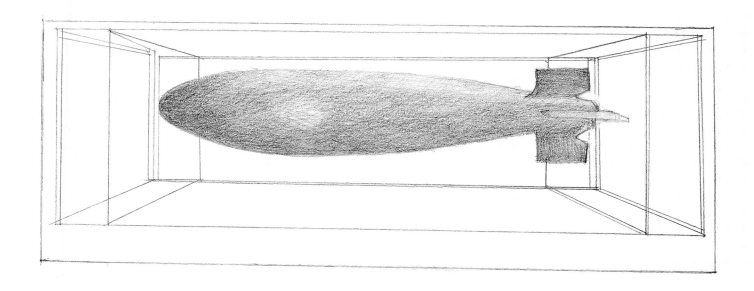

Bomb, 2009
Drawing on canvas
125.5 x 181 cm

MUSIC BOX

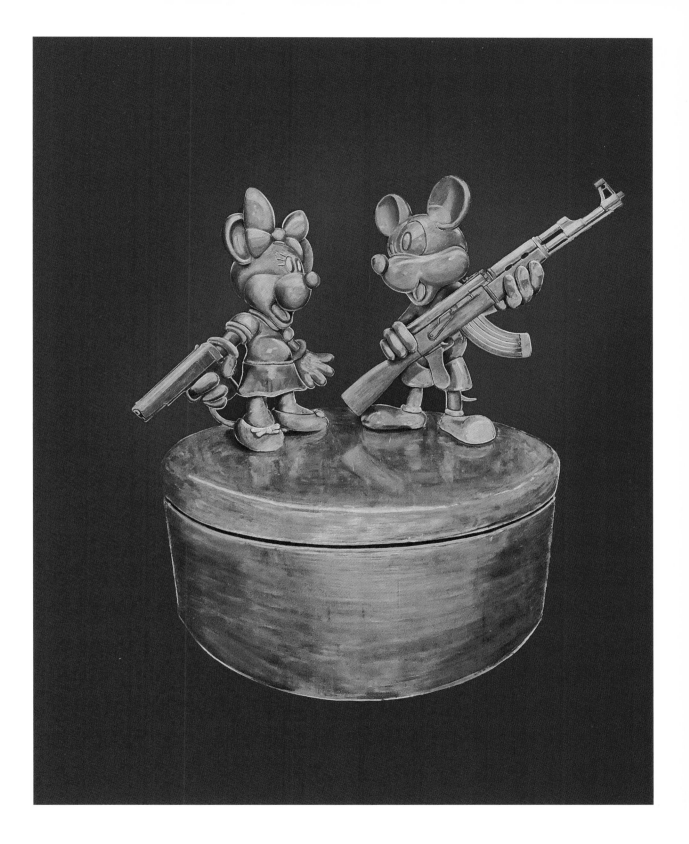

Mickey & Minnie I, 2012
Chalk on chalkboard
60 x 45 cm

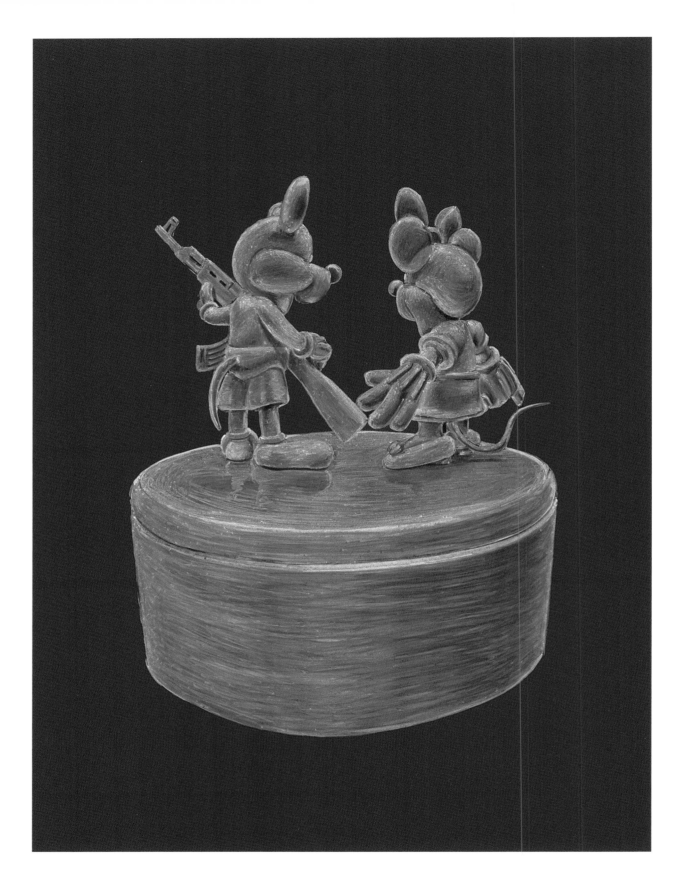

Mickey & Minnie II, 2012
Chalk on chalkboard
60 x 45 cm

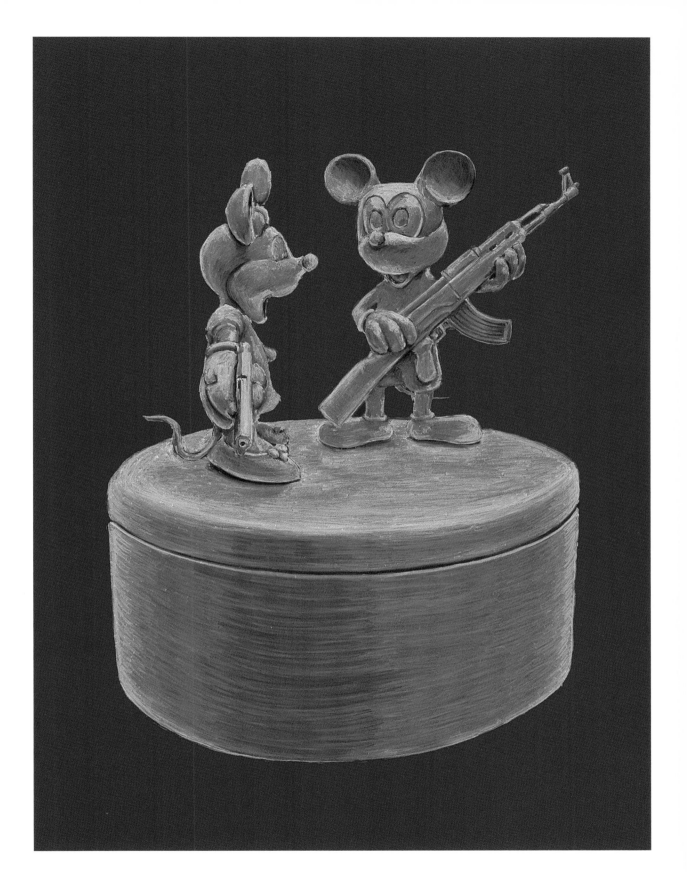

Mickey & Minnie III, 2012
Chalk on chalkboard
60 x 45 cm

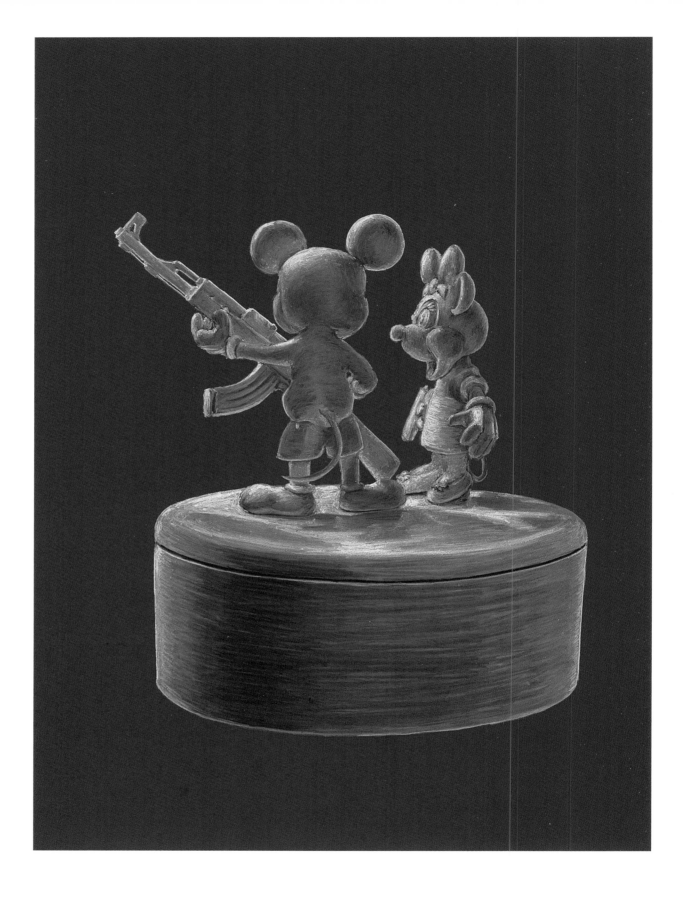

Mickey & Minnie IV, 2012
Chalk on chalkboard
60 x 45 cm

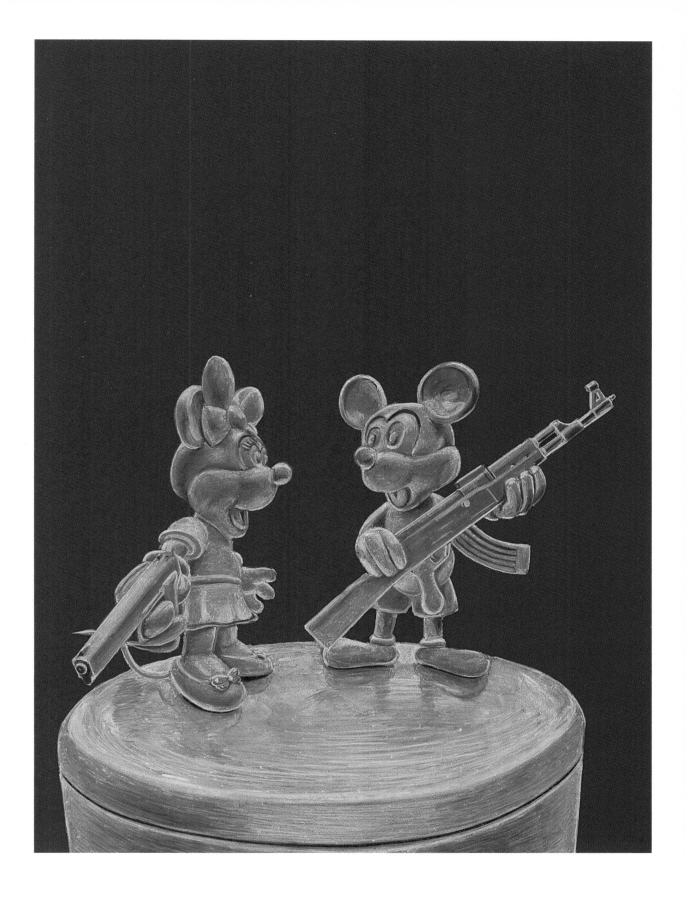

Mickey & Minnie V, 2012
Chalk on chalkboard
60 x 45 cm

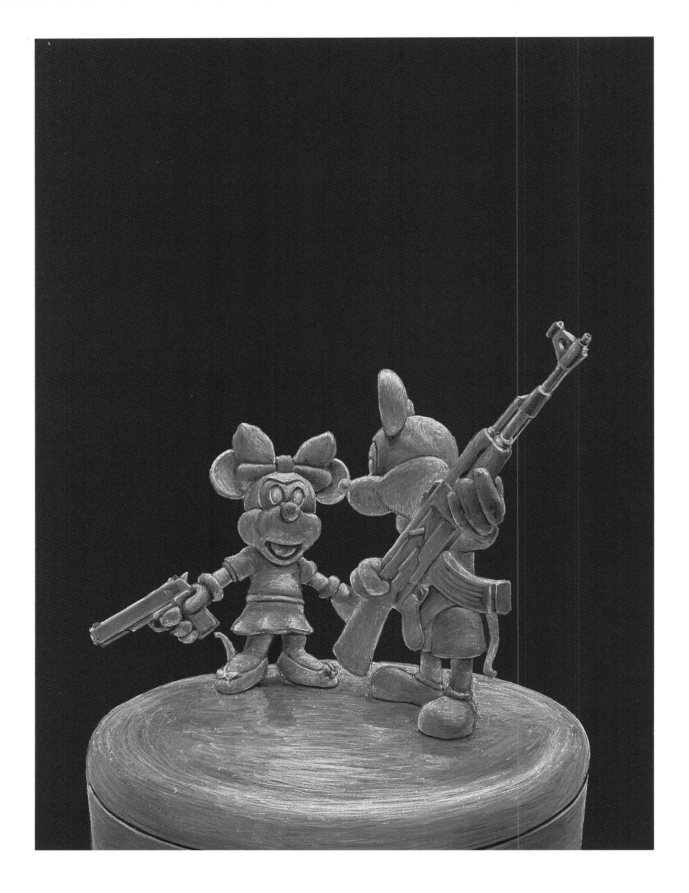

Mickey & Minnie VI, 2012
Chalk on chalkboard
60 x 45 cm

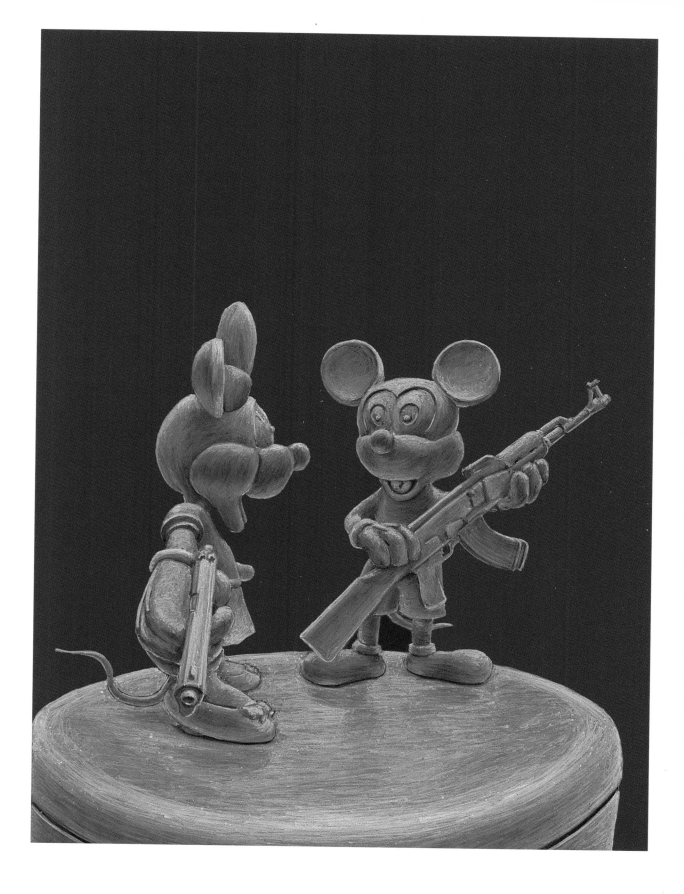

Mickey & Minnie VII, 2012
Chalk on chalkboard
60 x 45 cm

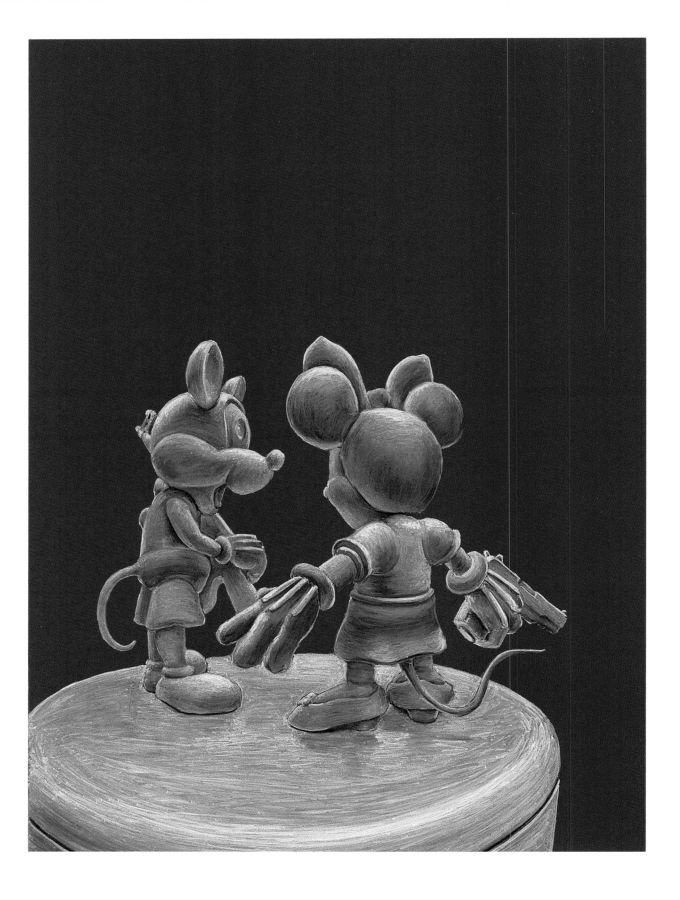

Mickey & Minnie VIII, 2012
Chalk on chalkboard
60 x 45 cm

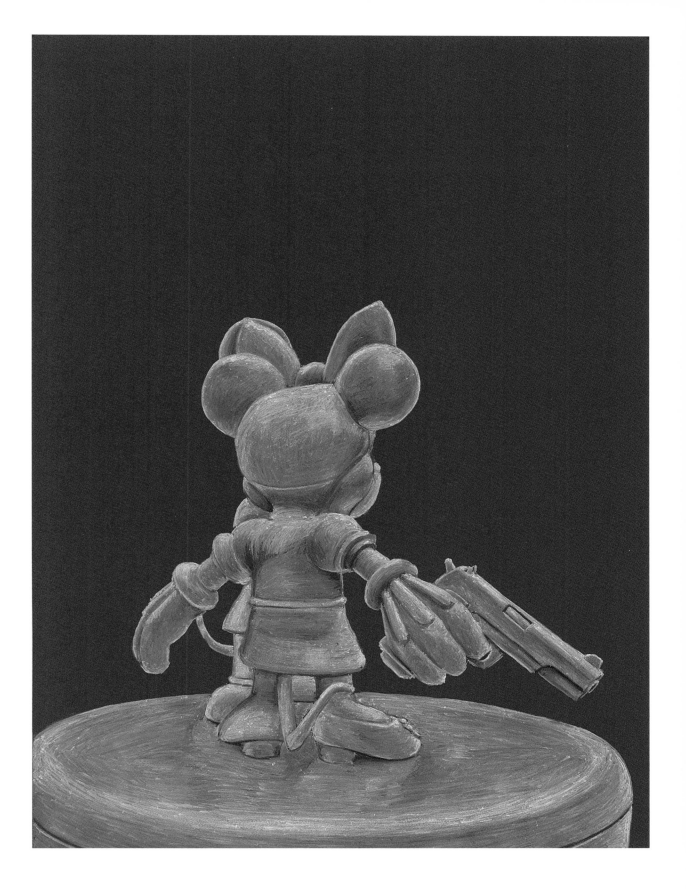

Mickey & Minnie IX, 2012
Chalk on chalkboard
60 x 45 cm

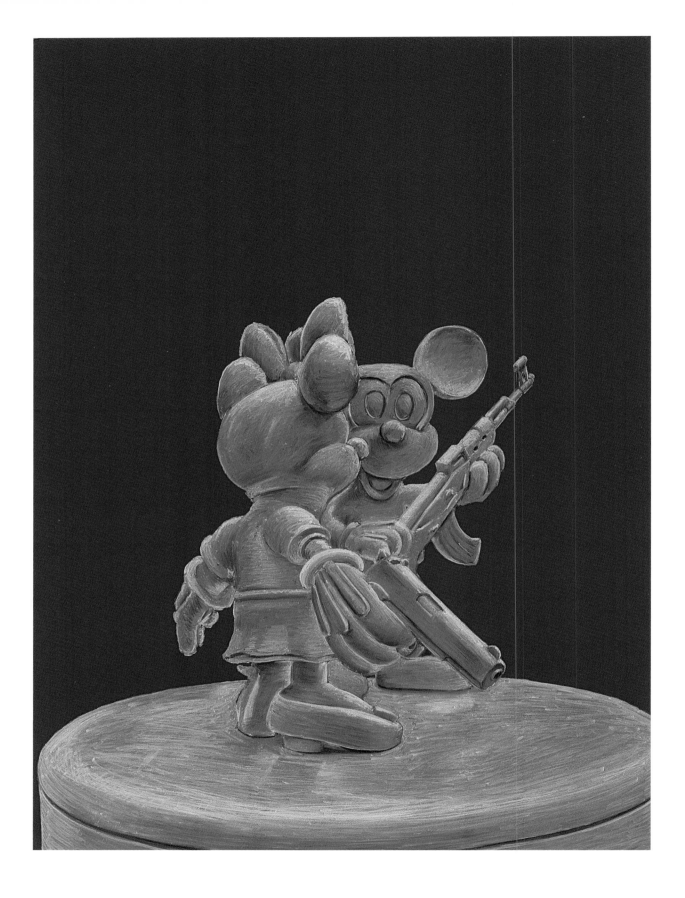

Mickey & Minnie X, 2012
Chalk on chalkboard
60 x 45 cm

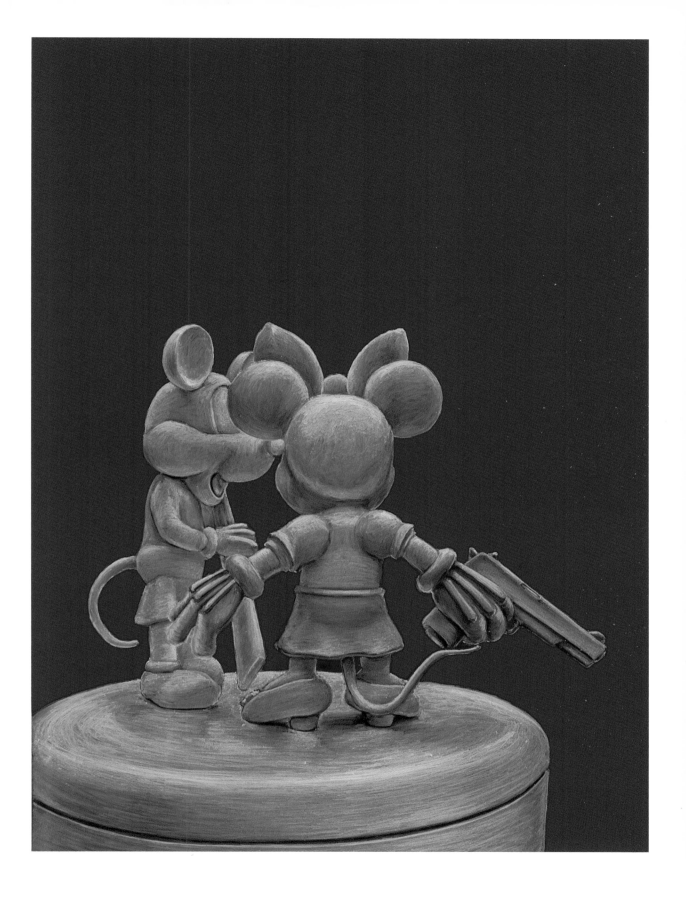

Government "Saddle", 2013
(right board of triptych)
Chalk on chalkboard
200 x 150 cm

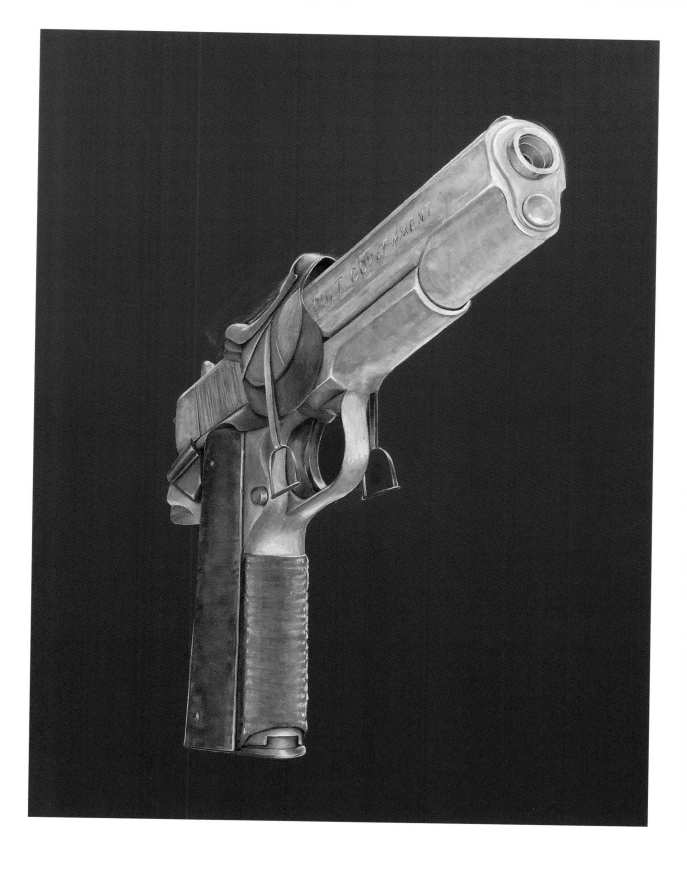

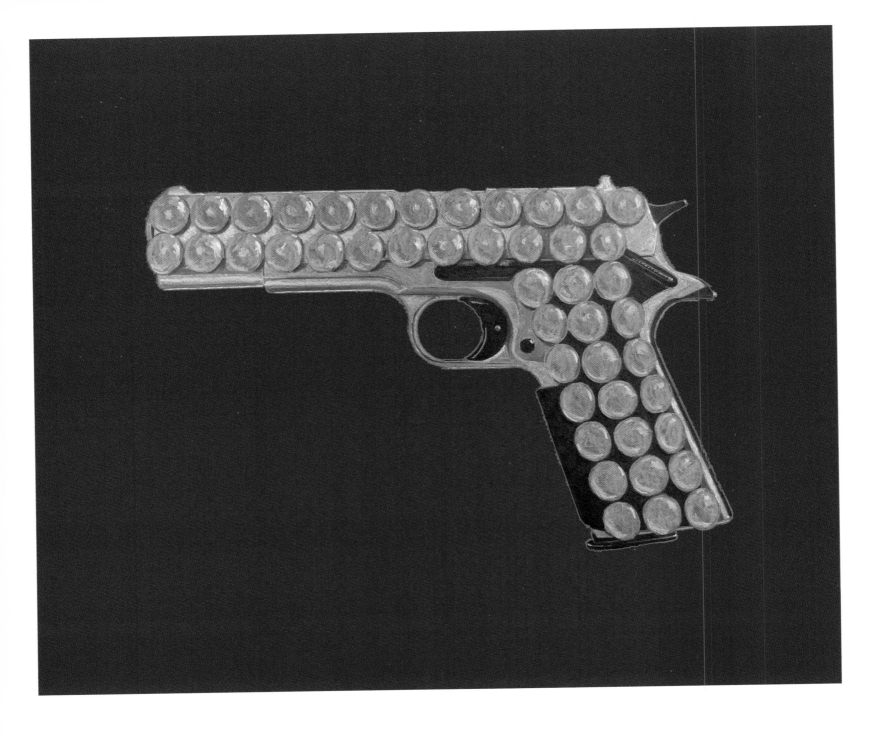

Government (pink), 2013
Chalk on chalkboard
50 x 60 cm

Pineapple (blue), 2013
Chalk on chalkboard
60 x 50 cm

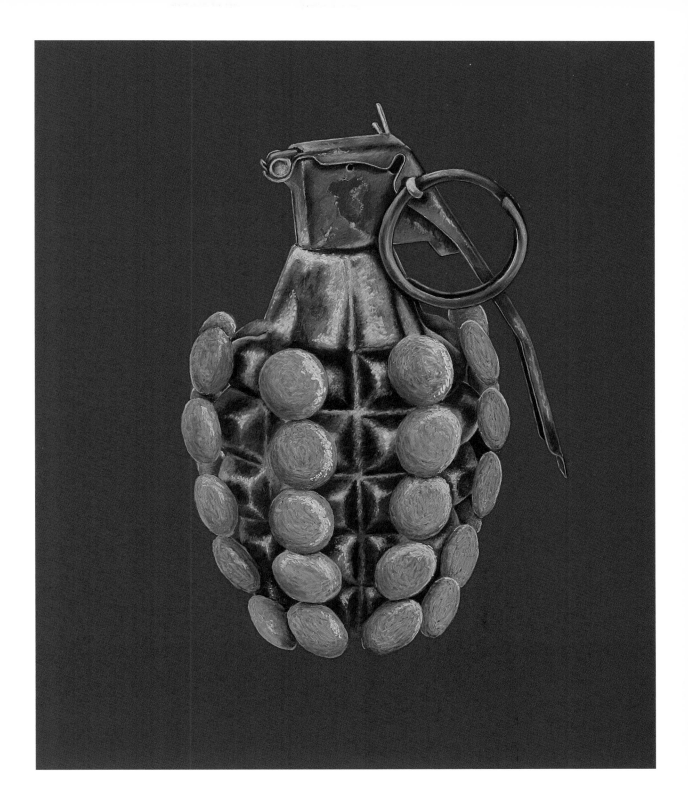

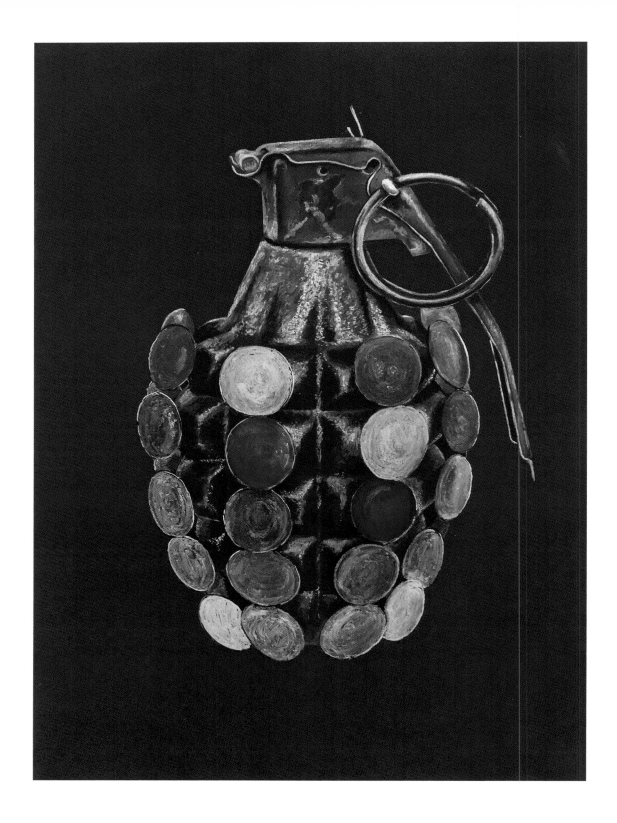

Government "Saddle", 2013
(left board of triptych)
Chalk on chalkboard
200 x 150 cm

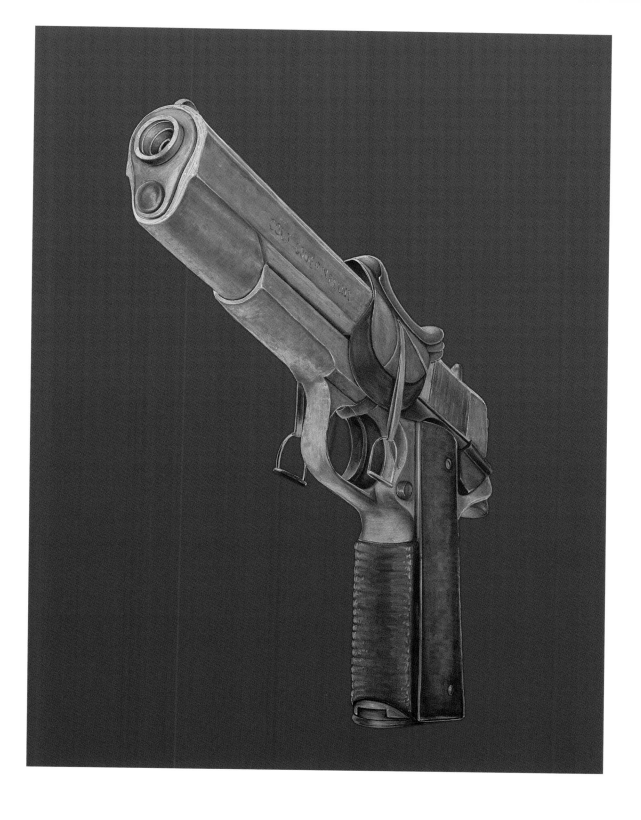

Pineapple "Flower" (multicolor),
2013
Chalk on chalkboard
60 x 50 cm

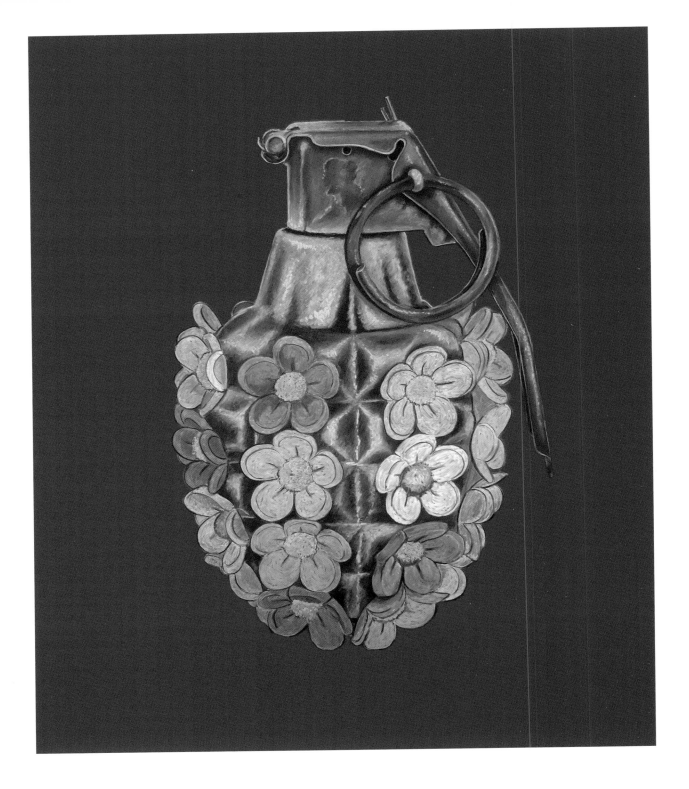

Pineapple (multicolor), 2013
Chalk on chalkboard
60 x 50 cm

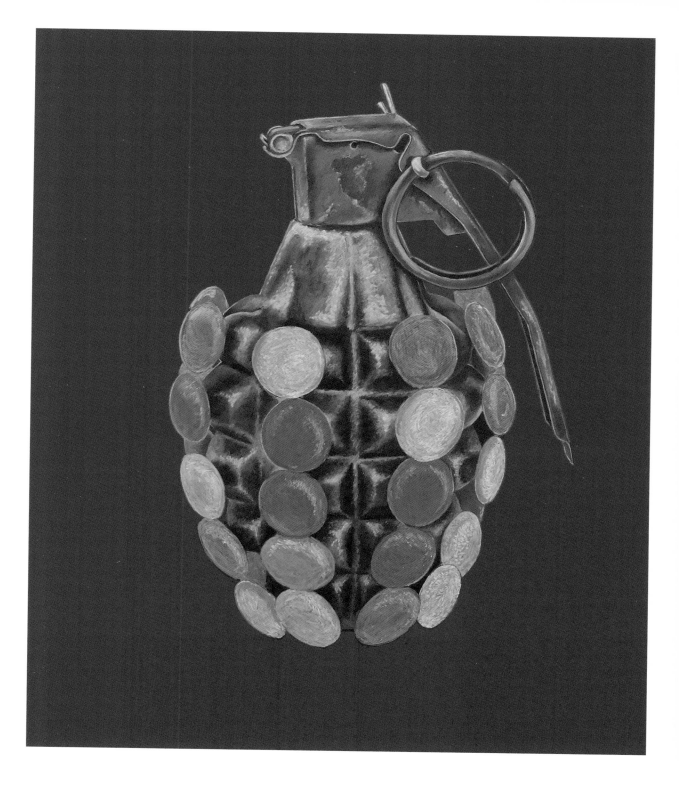

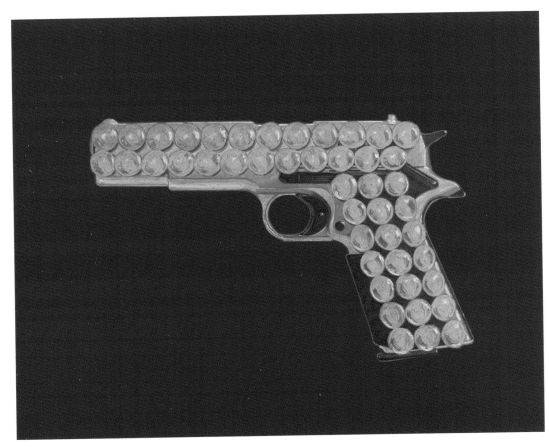

Government (yellow), 2013
Chalk on chalkboard
50 x 60 cm

Government (green), 2013
Chalk on chalkboard
50 x 60 cm

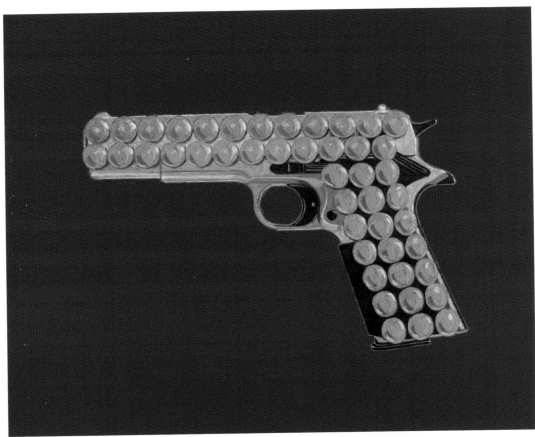

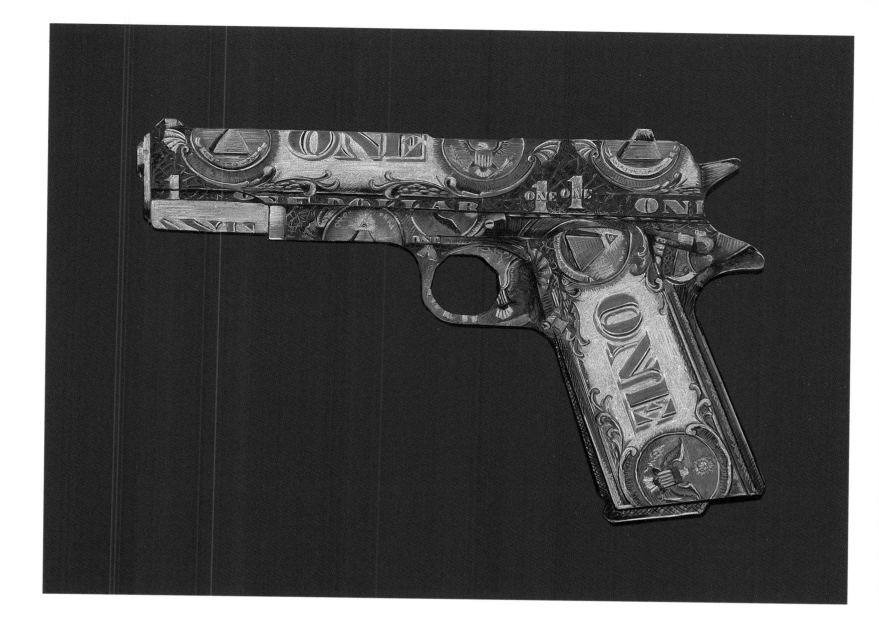

Government "US Dollar", 2012
Chalk on chalkboard
45 x 60 cm

Blackbird "US Dollar", 2012
Chalk on chalkboard
60 x 45 cm

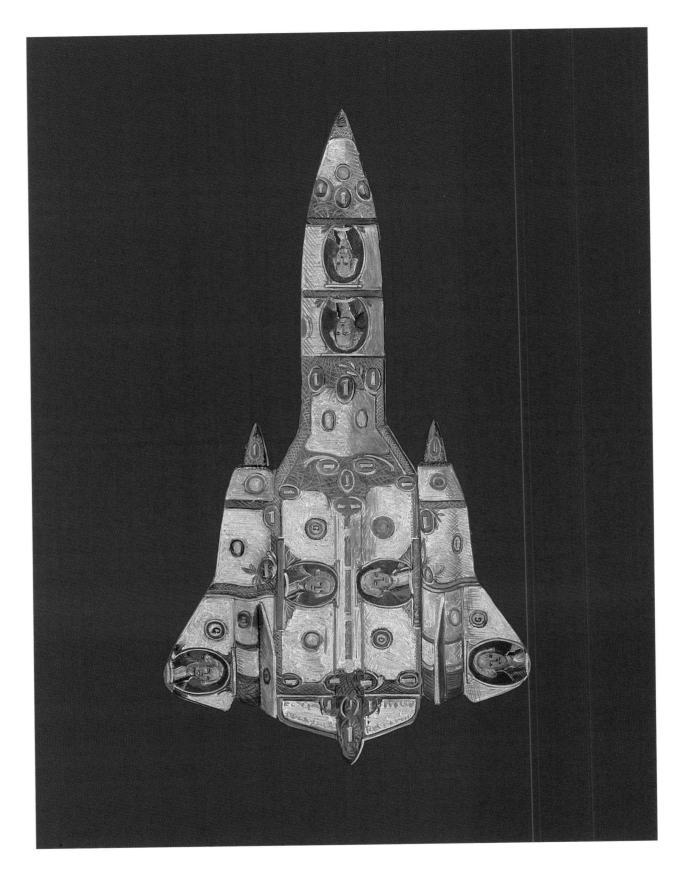

Bullet "US Dollar", 2012
Chalk on chalkboard
60 x 45 cm

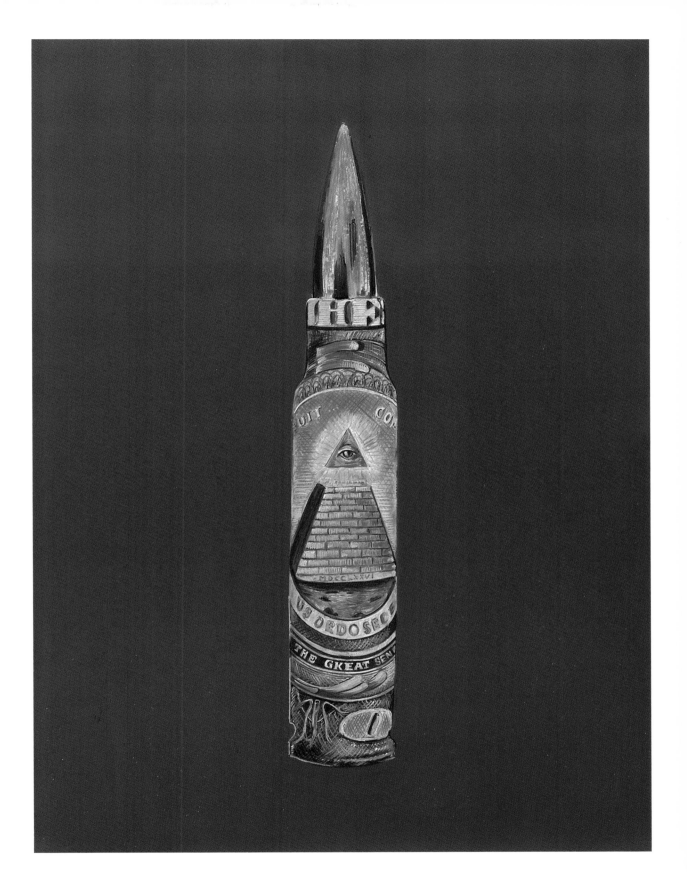

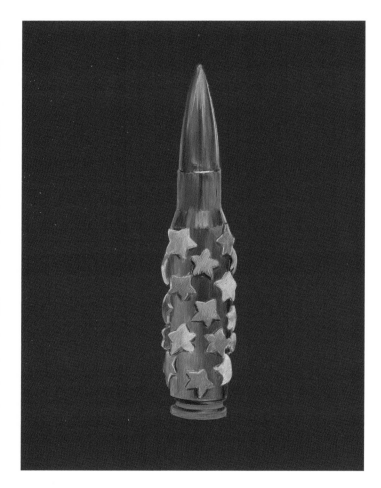

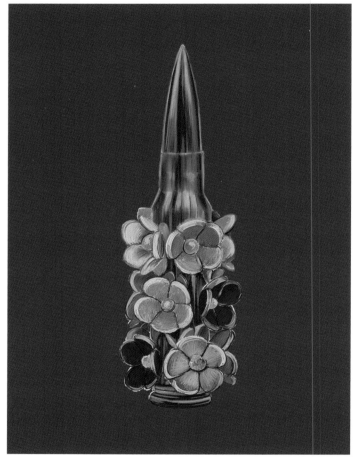

Bullet "Stars and Stripes", 2012
Chalk on chalkboard
60 x 45 cm

Bullet "Flower" (multicolor), 2012
Chalk on chalkboard
60 x 45 cm

Skull "Flower", 2012
Chalk on chalkboard
60 x 45 cm

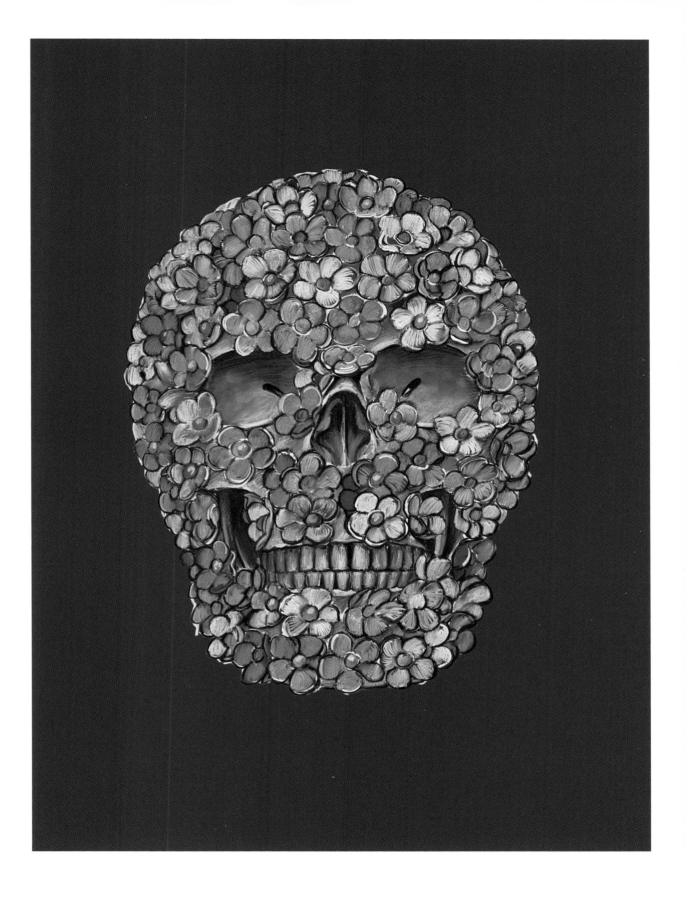

Skull "Comic", 2012
Chalk on chalkboard
60 x 45 cm

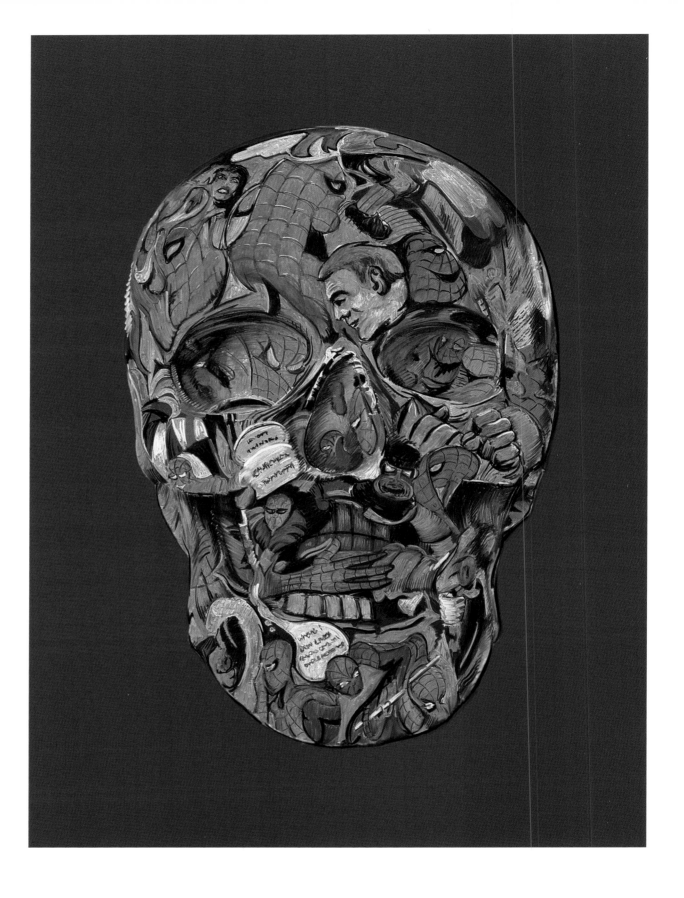

Hero "Spiderman", 2012
Chalk on chalkboard
60 x 45 cm

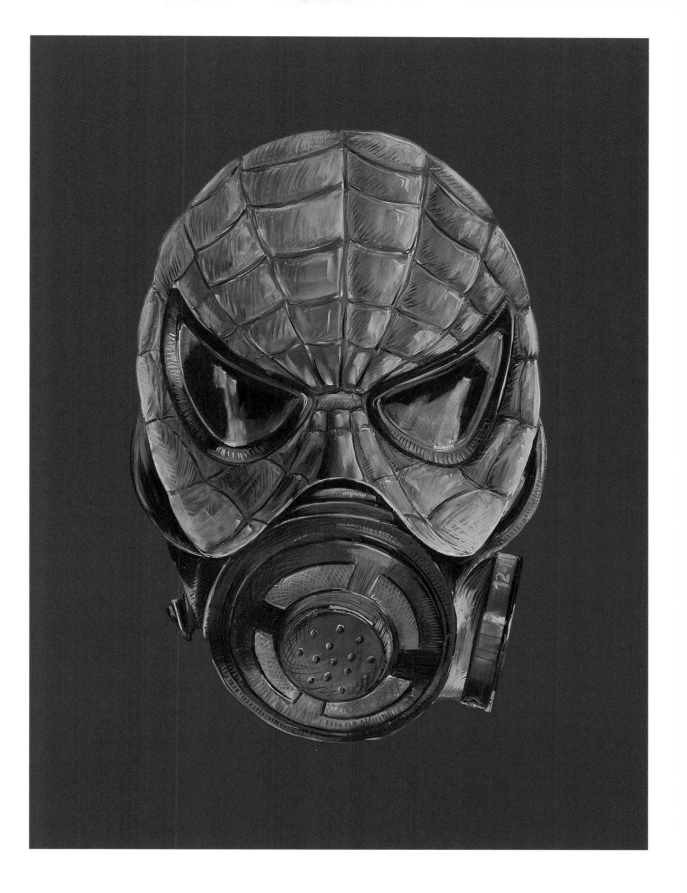

73

Hero "Spiderman II", 2012
Chalk on chalkboard
60 x 45 cm

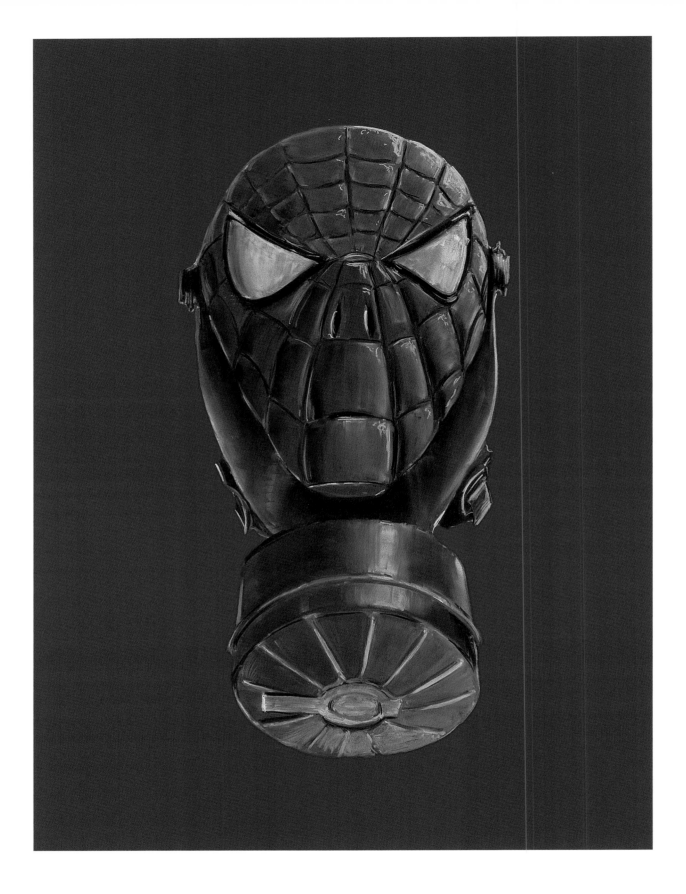

Hero "Iron Man", 2012
Chalk on chalkboard
60 x 45 cm

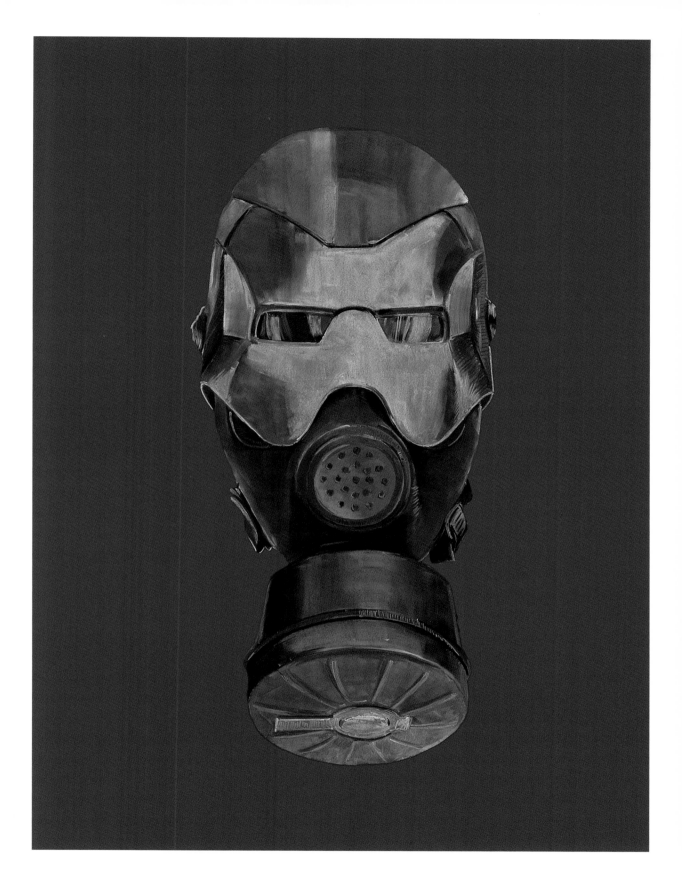

Hero "Wolverine", 2012
Chalk on chalkboard
60 x 45 cm

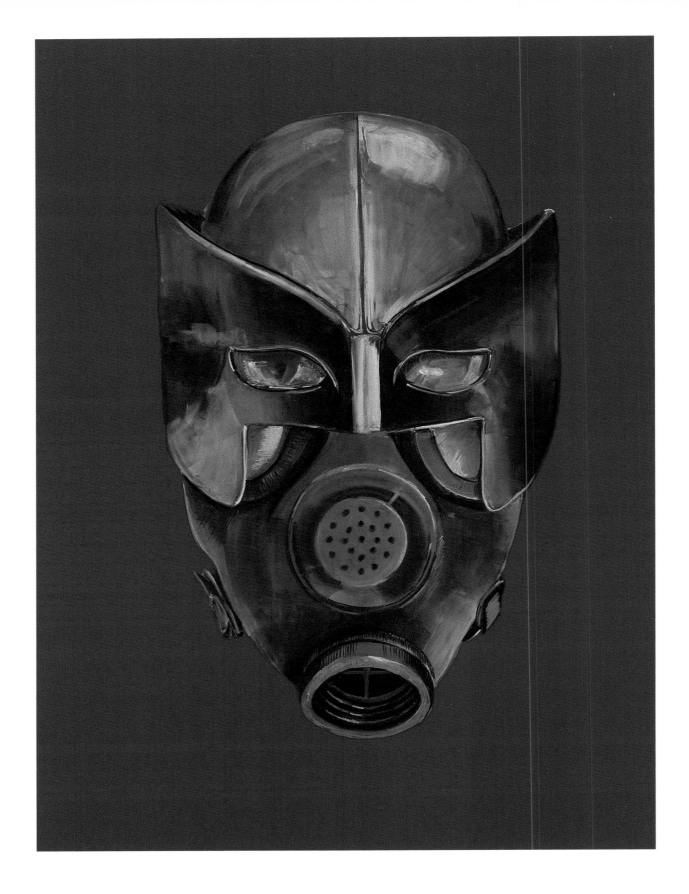

Hero "Captain America", 2012
Chalk on chalkboard
60 x 45 cm

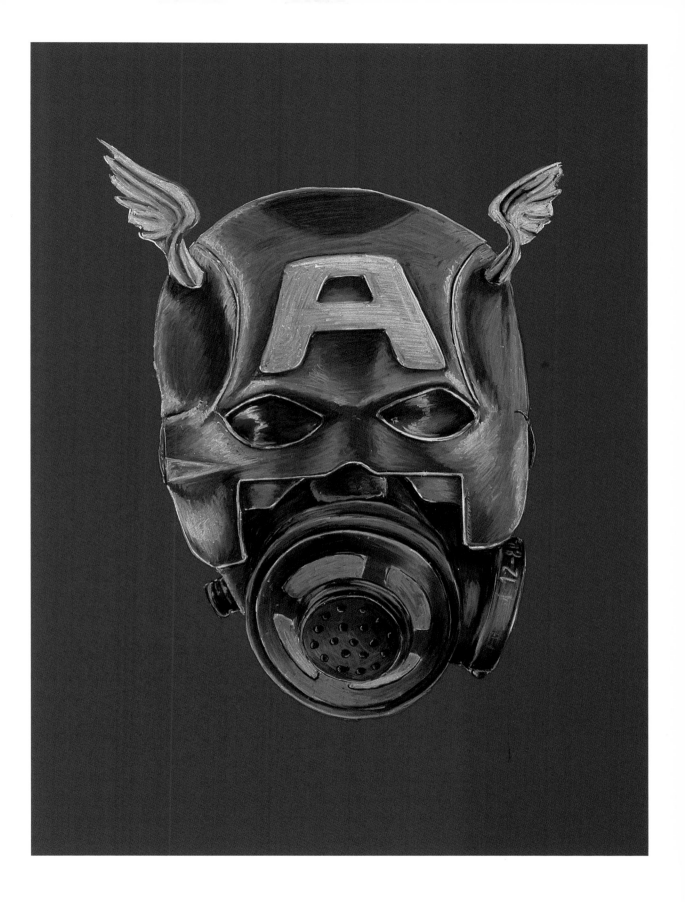

Catwoman, 2012
Chalk on chalkboard
60 x 45 cm

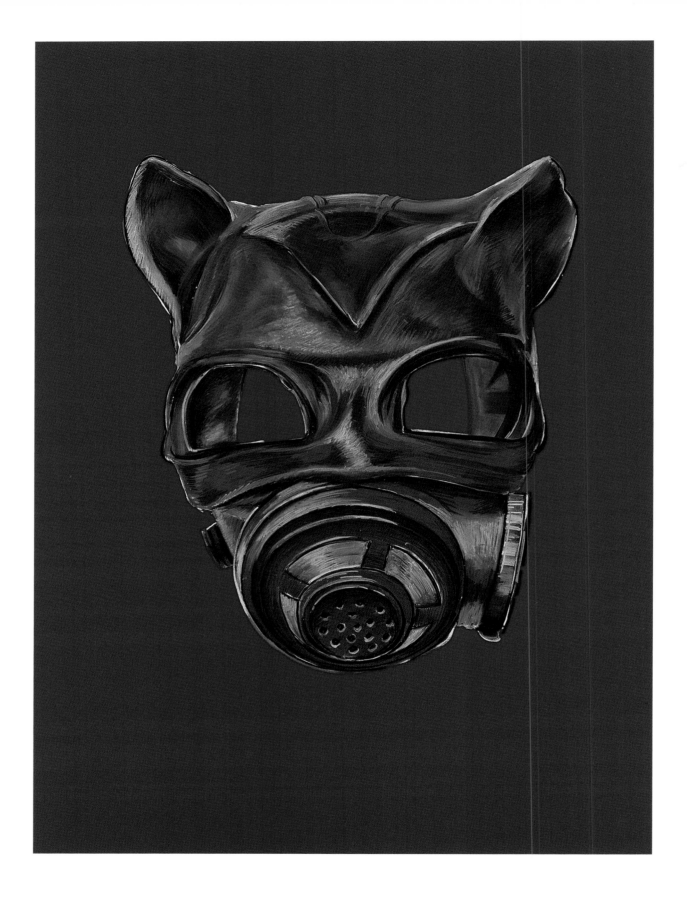

Hero "Thor", 2012
Chalk on chalkboard
60 x 45 cm

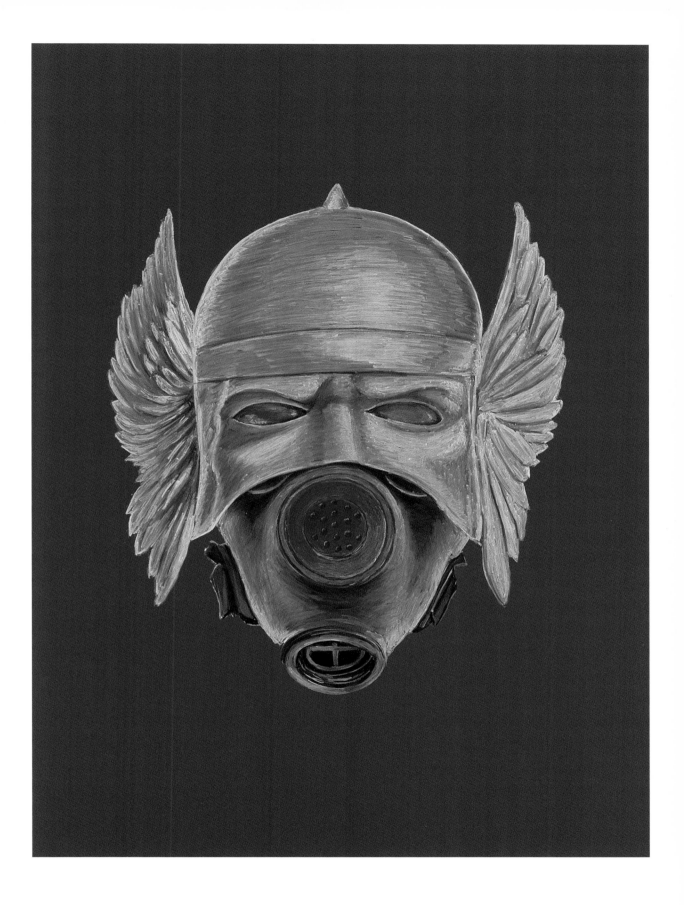

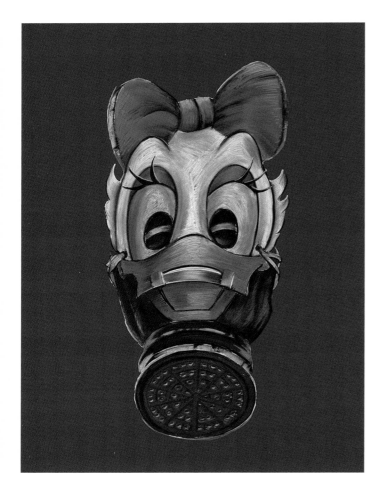

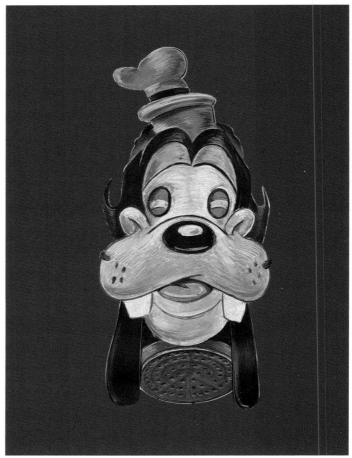

*Disney "Dagobert"*, 2012
Chalk on chalkboard
60 x 45 cm

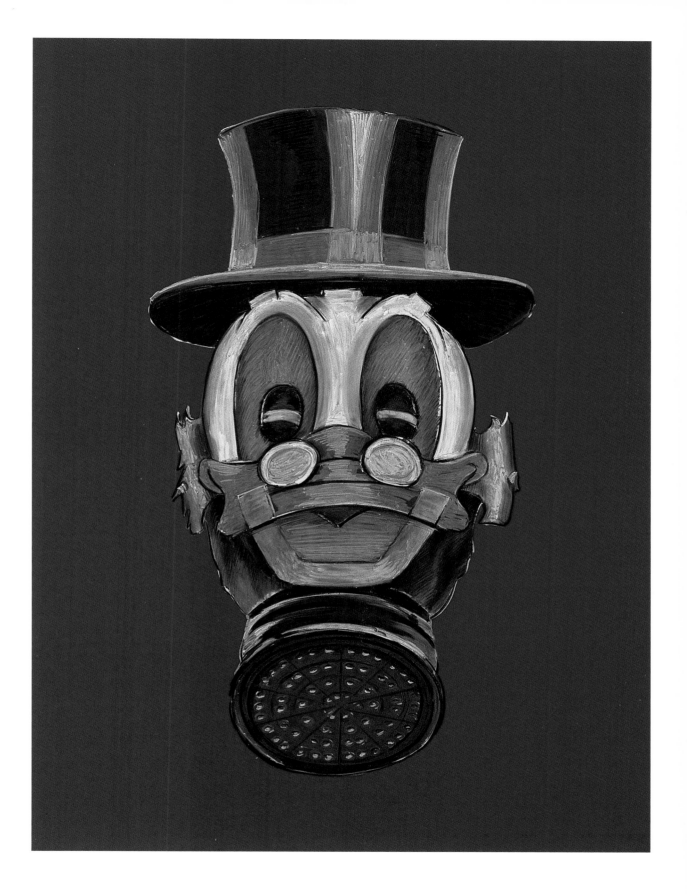

Disney "Mickey", 2012
Chalk on chalkboard
60 x 45 cm

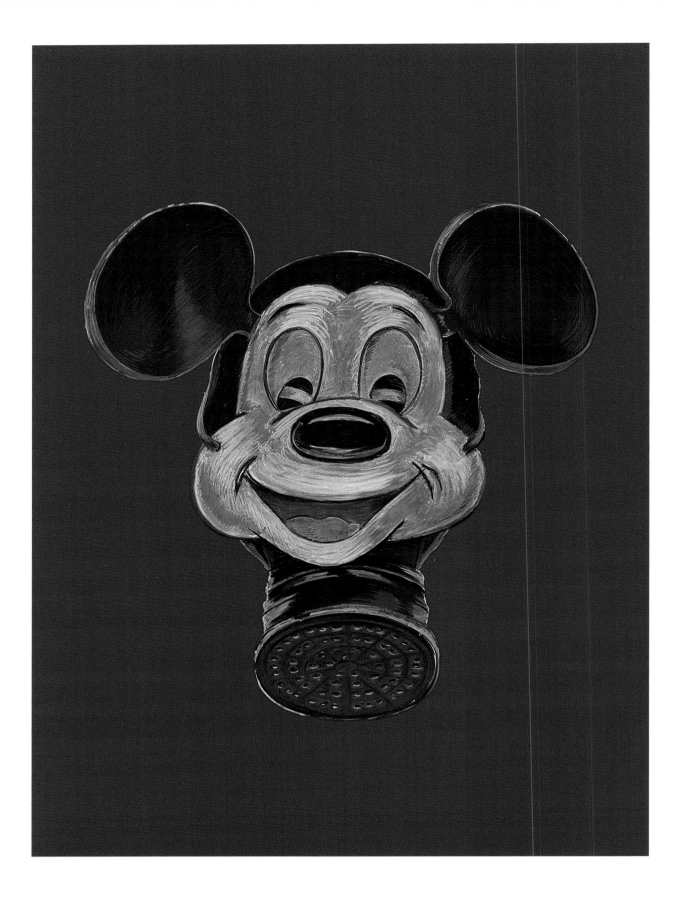

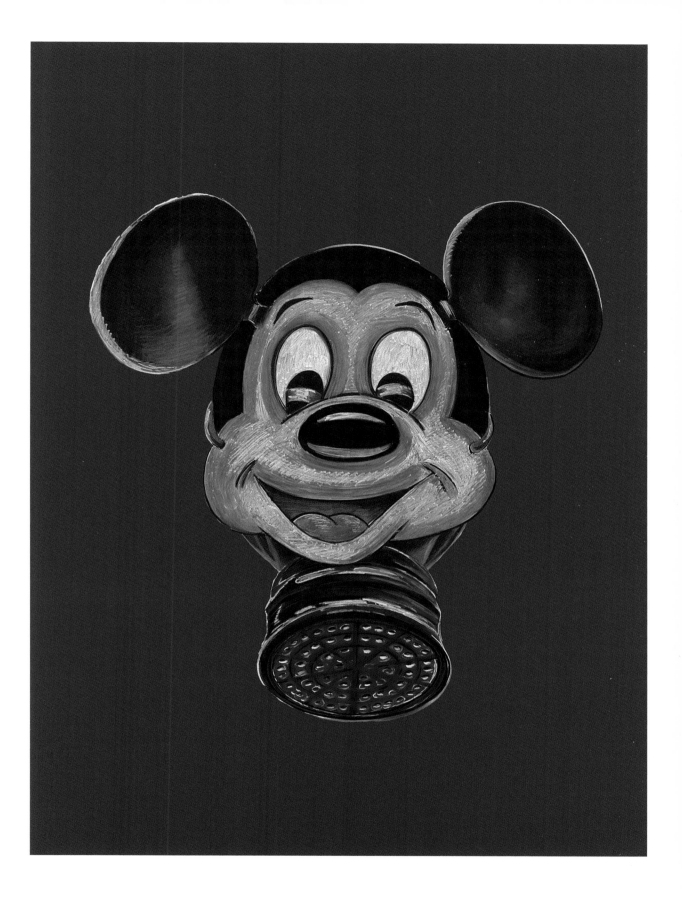

Mickey, Pearl Harbor 8, 2012
Chalk on chalkboard
60 x 45 cm

Mickey, Pearl Harbor 7, 2012
Chalk on chalkboard
60 x 45 cm

Mickey, Pearl Harbor 9, 2012
Chalk on chalkboard
60 x 45 cm

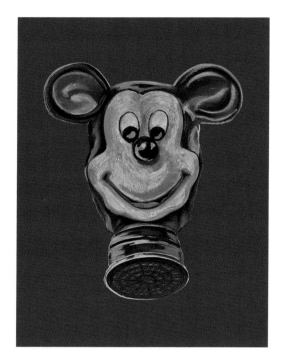

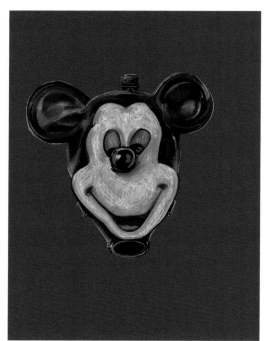

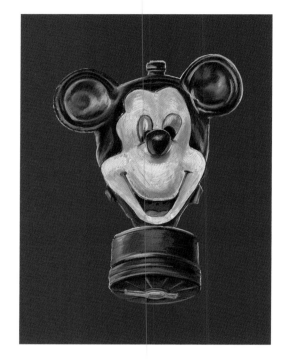

Disney "Minnie", 2012
Chalk on chalkboard
60 x 45 cm

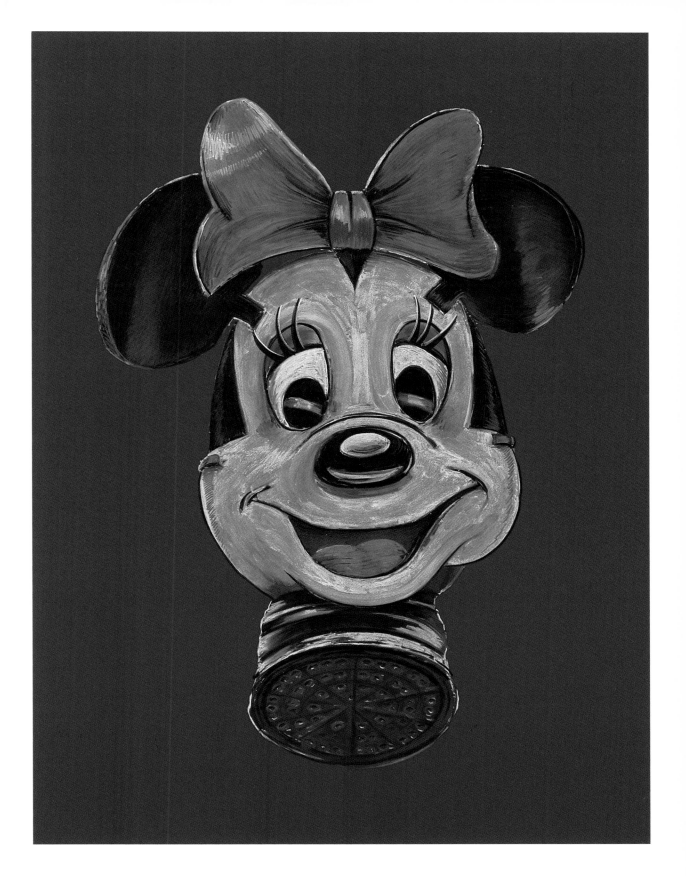

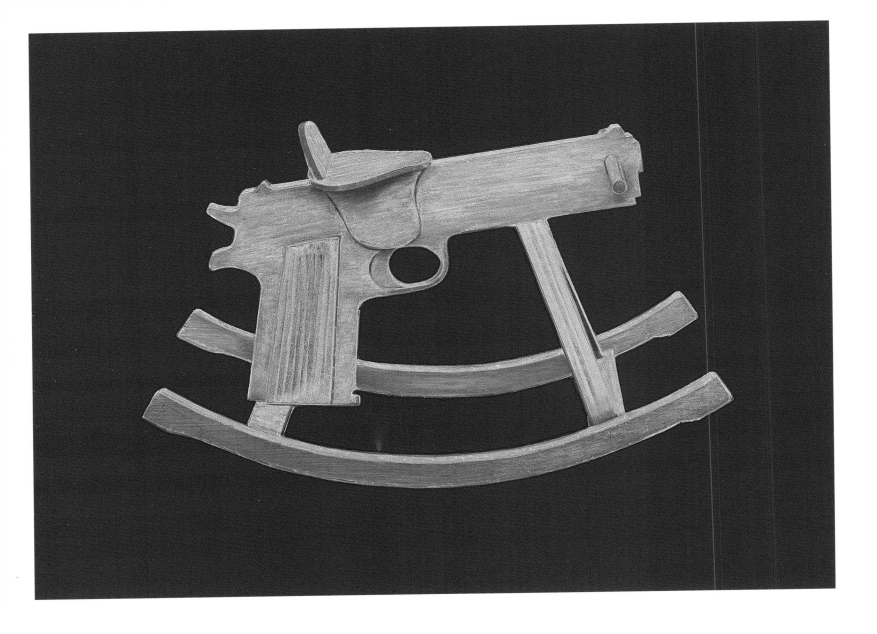

Cheval à bascule, 2012
Chalk on chalkboard
45 x 60 cm

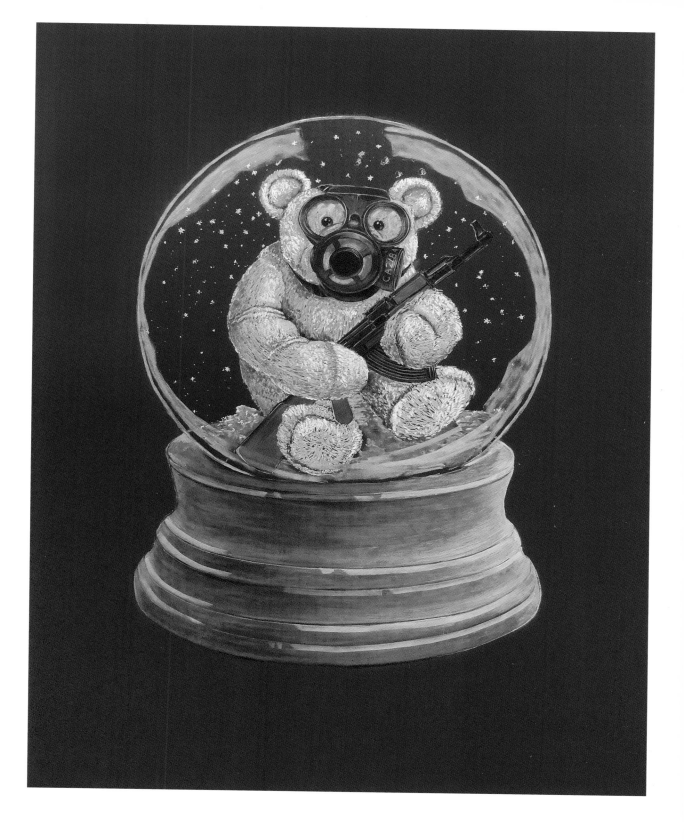

Little Boy I, 2012
Chalk on chalkboard
45 x 60 cm

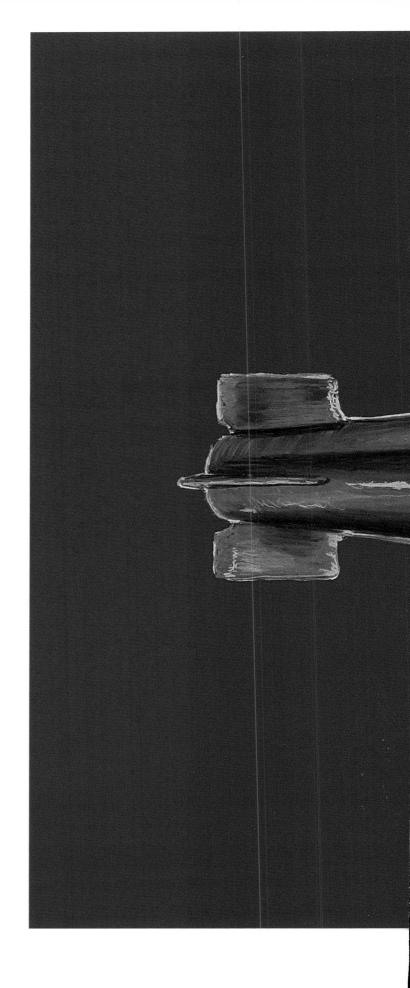

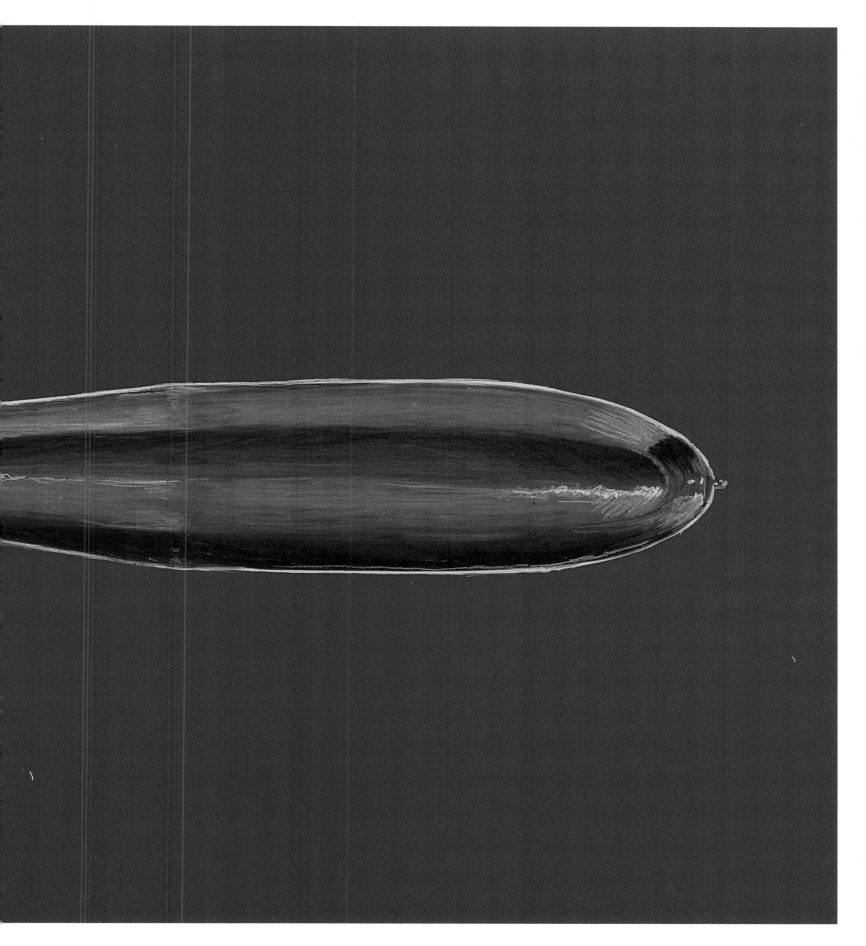

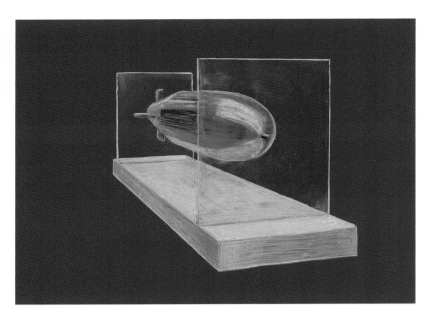

Little Boy III, 2012
Chalk on chalkboard
45 x 60 cm

Little Boy II, 2012
Chalk on chalkboard
45 x 60 cm

Little Boy IV, 2012
Chalk on chalkboard
45 x 60 cm

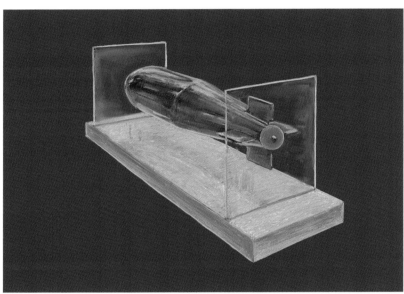

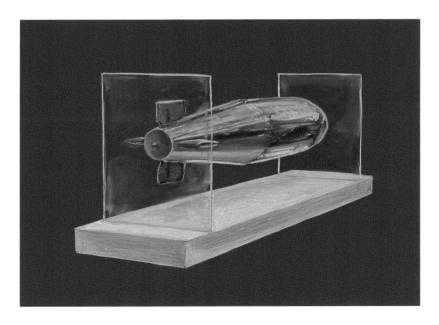

Little Boy V, 2012
Chalk on chalkboard
60 x 45 cm

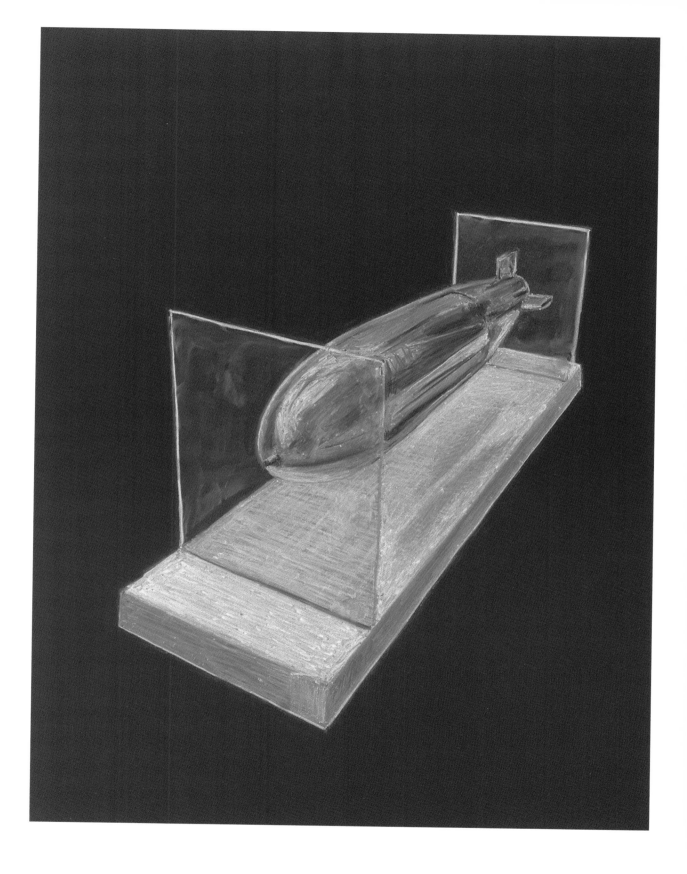

DRAFTS & SHAPES

Sketch for "Pink Bomb" and
"Cheval à bascule", 2009
Coloured pencil and pencil on paper
21.9 x 13.6 cm

Sketch for "Skull 'Flower'", 2011
Coloured pencil and pen on paper
21 x 29.4 cm

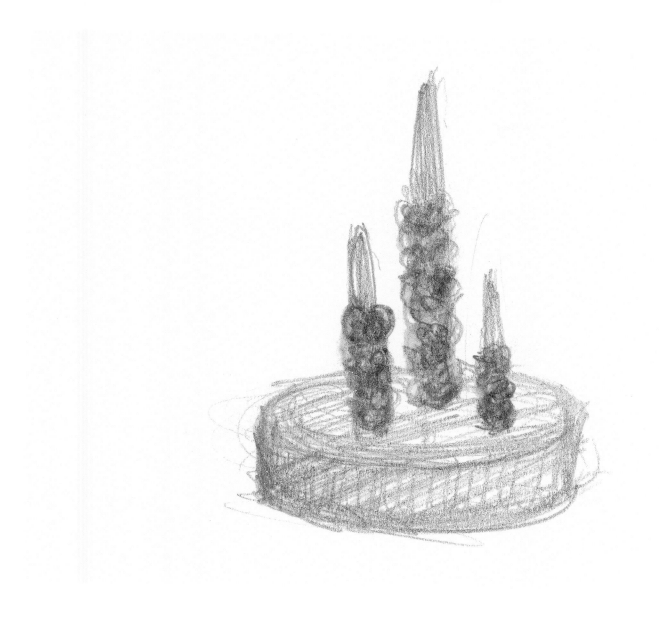

Sketch for Sculpture "Bullets
'Flower' on Music Box", 2011
Coloured pencil and pencil on paper
21 x 29.4 cm

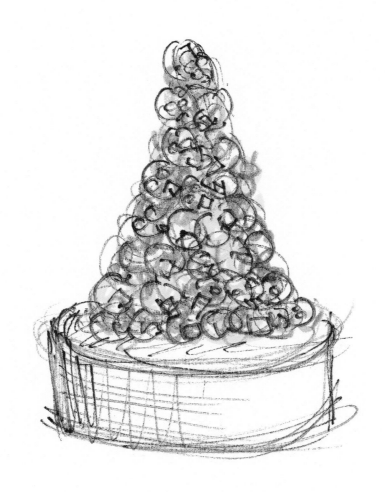

Sketch for "Skulls on Music Box",
2011
Coloured pencil and pen on paper
21 x 29.4 cm

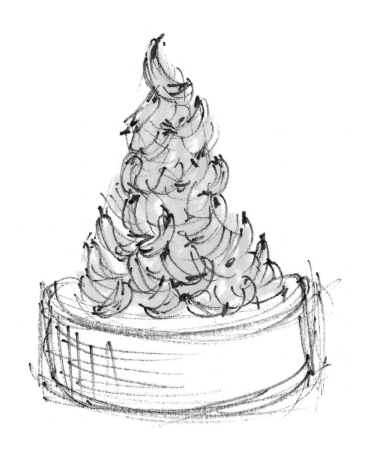

*Sketch for "Bananas on Music
Box"*, 2011
Coloured pencil and pen on paper
21 x 29.4 cm

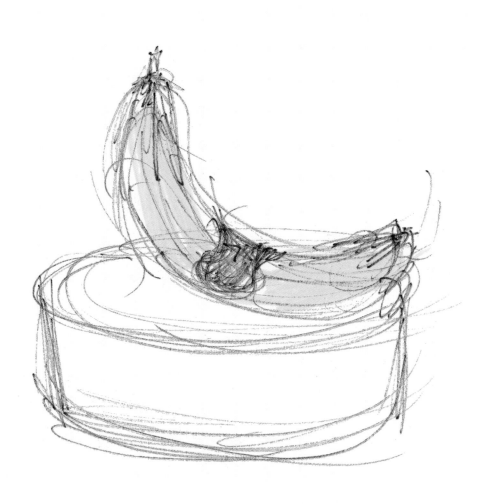

Sketch for "Banana Swing
Music Box", 2011
Coloured pencil and pen on paper
21 x 29.4 cm

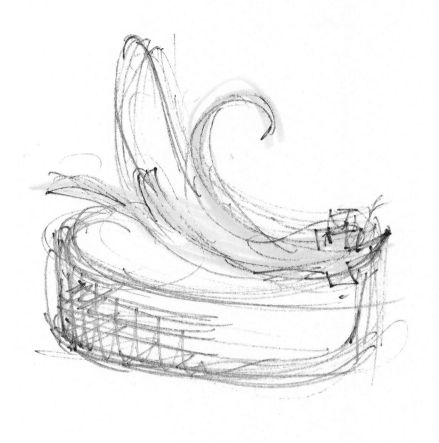

Sketch for "Banana-Bomb
Music Box", 2011
Coloured pencil and pen on paper
21 x 29.4 cm

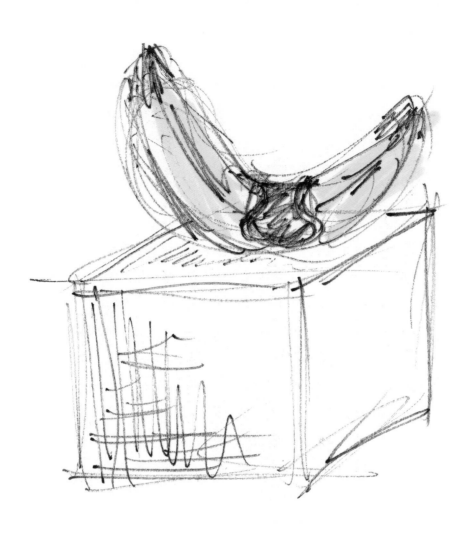

*Sketch for Sculpture "Banana
Swing"*, 2011
Coloured pencil and pen on paper
21 x 29.4 cm

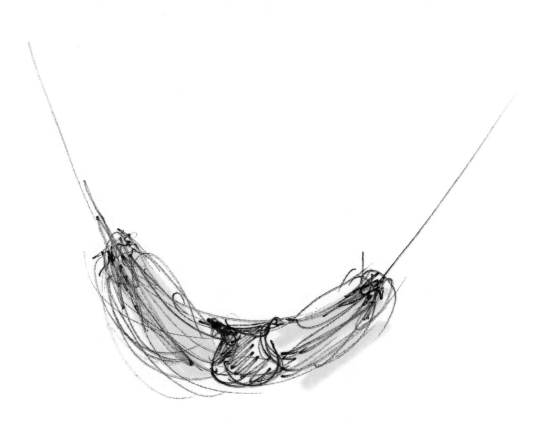

Sketch for "Banana Swing", 2011
Coloured pencil and pen on paper
21 x 29.4 cm

Sketch for Sculpture "Warrior",
2010
Pen on paper
10.5 x 14.7 cm

*Sketch for Sculpture "Warrior
Man and Woman",* 2010
Pen on paper
10.5 x 12.6 cm

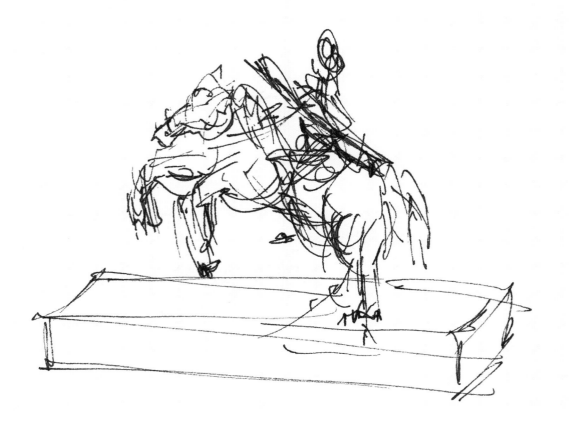

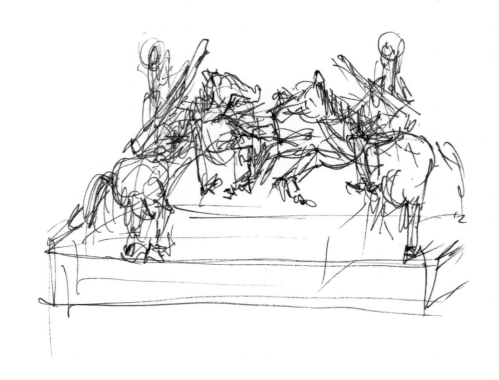

Sketch for Sculpture "Flying Horses", 2010
Pen on paper
21.9 x 15.6 cm

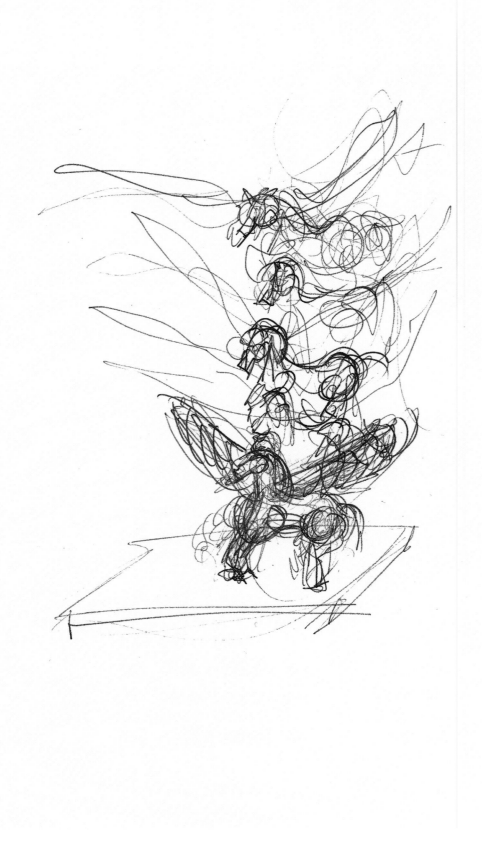

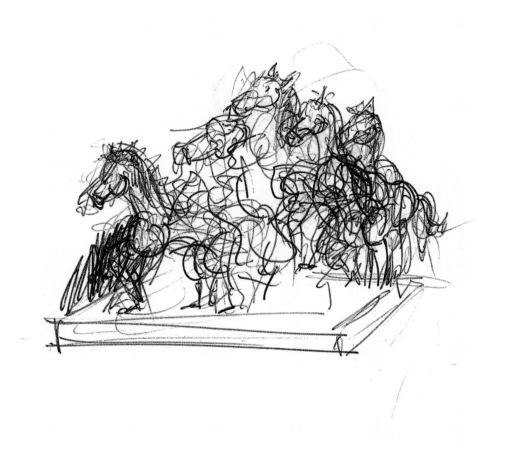

Sketch for Sculpture
"Rearing Horses", 2010
Pen on paper
15.6 x 21.9 cm

Denix Remington, 2011
Coloured pencil and pencil on paper
21 x 14.8 cm

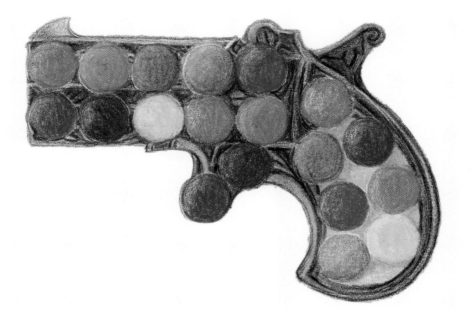

Butterfly-Gun (red), 2013
Coloured pencil and pencil on paper
21 x 14.8 cm

Butterfly-Gun (blue), 2013
Coloured pencil and pencil on paper
21 x 14.8 cm

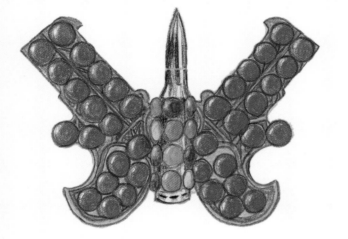

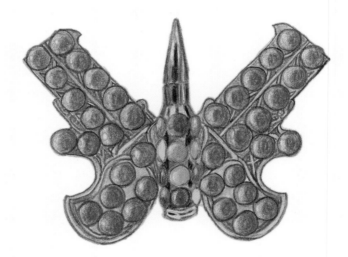

Butterfly-Gun (pink), 2013
Coloured pencil and pencil on paper
21 x 14.8 cm

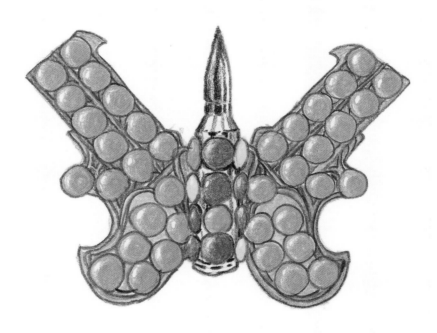

Butterfly-Government (blue), 2013
Coloured pencil and pencil on paper
21 x 14.8 cm

Butterfly-Government (red), 2013
Coloured pencil and pencil on paper
21 x 14.8 cm

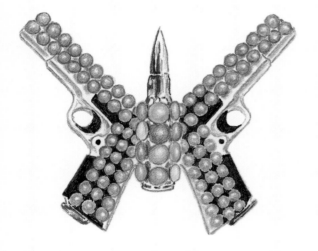

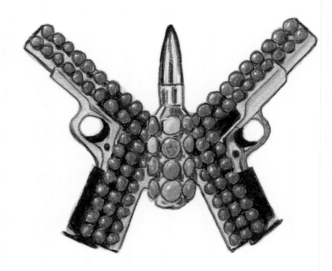

Butterfly-Government (multicolor),
2013
Coloured pencil and pencil on paper
21 x 14.8 cm

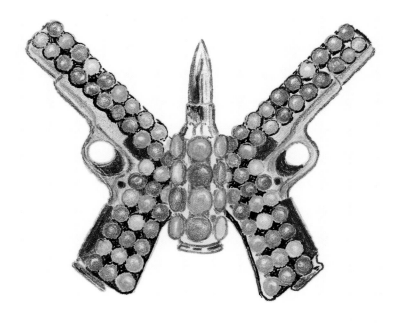

Butterfly-Government "US Dollar",
2013
Coloured pencil and pencil on paper
21 x 14.8 cm

Butterfly-Government "US Dollar"
(pink), 2013
Coloured pencil and pencil on paper
21 x 14.8 cm

Butterfly-Government "US Dollar"
(blue), 2013
Coloured pencil and pencil on paper
21 x 14.8 cm

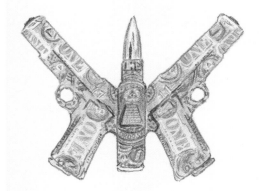

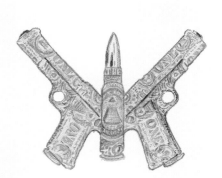

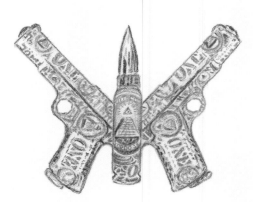

Butterfly "US Dollar" I, 2013
Coloured pencil and pencil on paper
21 x 14.8 cm

Butterfly "US Dollar" II, 2013
Coloured pencil and pencil on paper
21 x 14.8 cm

Butterfly "US Dollar" III, 2013
Coloured pencil and pencil on paper
14 x 19.7 cm

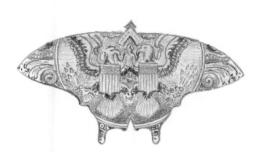

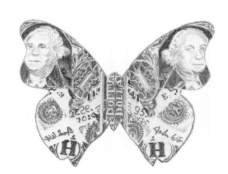

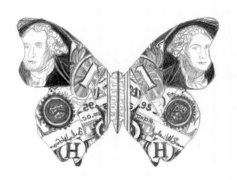

Pineapple "Flower", 2011
Coloured pencil and pencil on paper
21 x 14.8 cm

Bullet "Flower" (multicolor), 2012
Coloured pencil and pencil on paper
21 x 14.8 cm

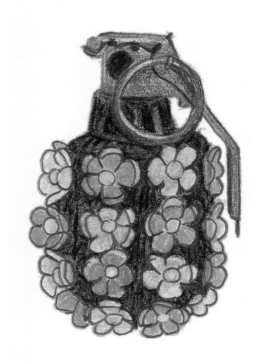

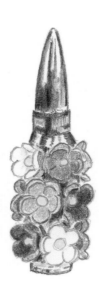

Skull "Flower", 2011
Coloured pencil and pencil on paper
21 x 14.8 cm

Government "Flower" (multicolor),
2013
Coloured pencil and pencil on paper
21 x 14.8 cm

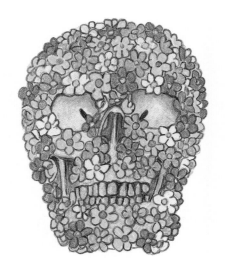

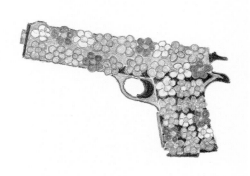

Disney "Dagobert", 2011
Coloured pencil and pencil on paper
21 x 14.8 cm

Disney "Daisy", 2011
Coloured pencil and pencil on paper
21 x 14.8 cm

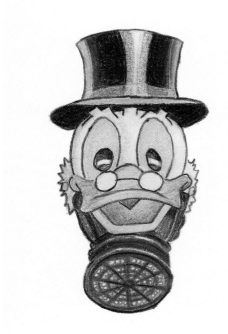

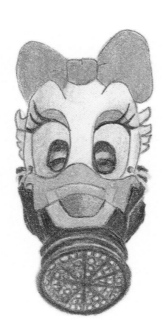

Hero "Captain America", 2011
Coloured pencil and pencil on paper
21 x 14.8 cm

Hero "Spiderman", 2011
Coloured pencil and pencil on paper
21 x 14.8 cm

Catwoman, 2011
Coloured pencil and pencil on paper
21 x 14.8 cm

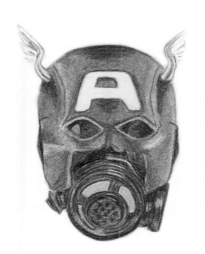

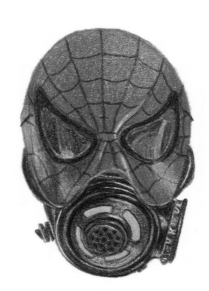

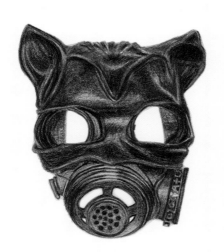

Cheval à bascule I, 2011
Coloured pencil and pencil on paper
21 x 14.8 cm

Cheval à bascule II, 2011
Coloured pencil and pencil on paper
21 x 14.8 cm

Cheval à bascule, 2013
Pencil on paper
14 x 19.7 cm

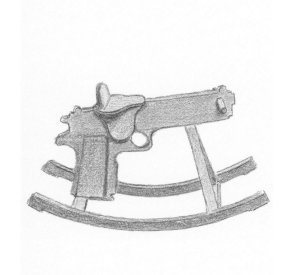

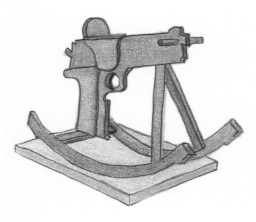

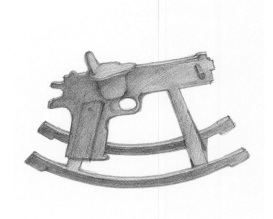

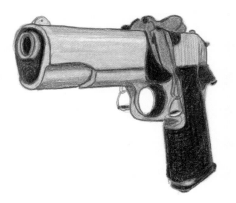

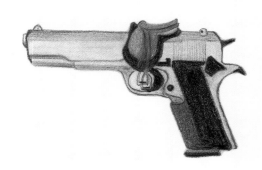

SKULLS & BANKNOTES

Skull "US Dollar" (blue), 2012
Acrylic on paper
40.7 x 28.7 cm

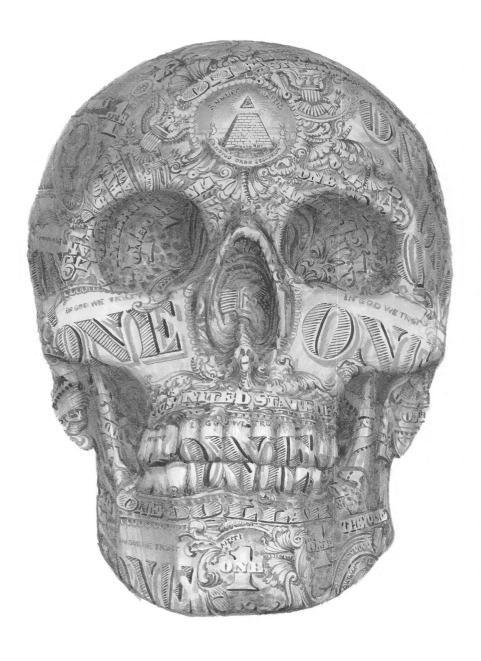

Skull "US Dollar" (green), 2012
Acrylic on paper
40.7 x 28.7 cm

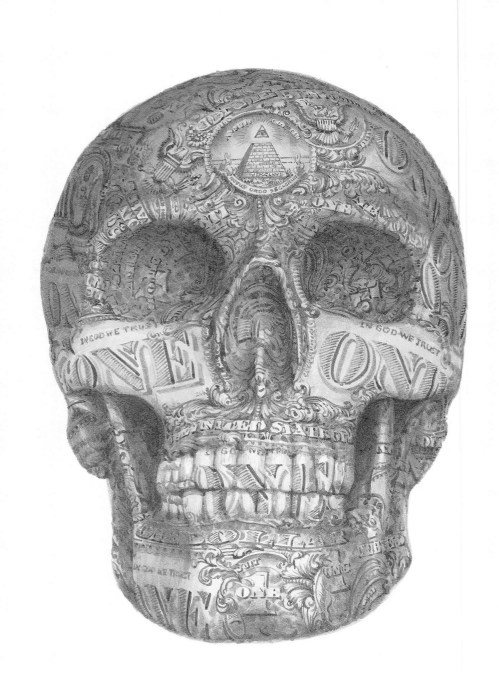

136

Skull "US Dollar" (yellow), 2012
Acrylic on paper
40.7 x 28.7 cm

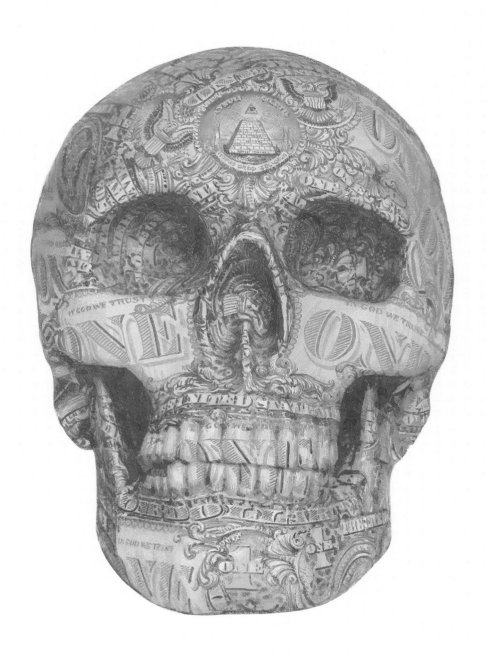

Skull "Splash" (pink), 2012
Watercolour on paper
40.7 x 28.7 cm

Skull "Splash" (yellow), 2012
Watercolour on paper
40.7 x 28.7 cm

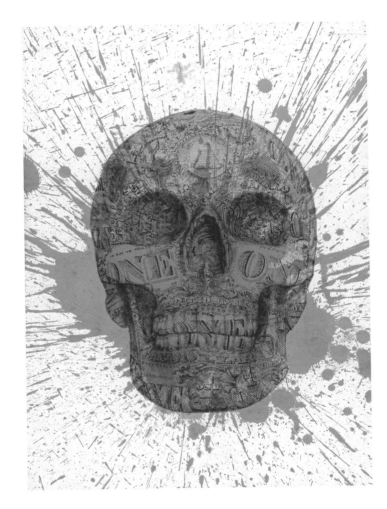

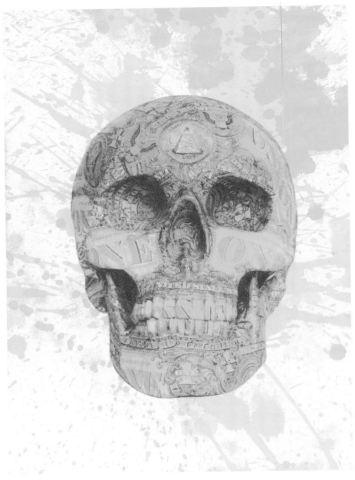

138

Skull "Splash" (blue), 2012
Watercolour on paper
40.7 x 28.7 cm

Skull "Splash" (green), 2012
Watercolour on paper
40.7 x 28.7 cm

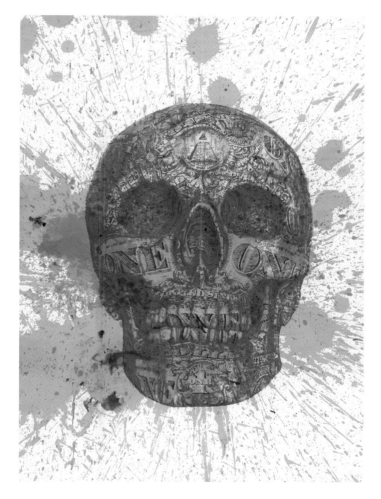

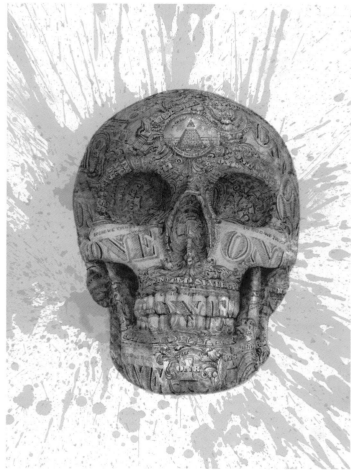

David Rosenberg

no second thoughts:

the work of kata legrady

Ever since her first creations, Kata Legrady's work has developed and deepened with no hesitation and no second thoughts. As clearly stated by Daniel Spoerri, her friend and mentor, it is as though she blossomed all at once after a long process of ripening, thought and reflection. And Legrady has indeed established herself on the international art scene after a number of shows and publications, and now exhibits with equal success in Europe, Asia and the United States.

While attempts are sometimes made to explain her trajectory by putting forward the names of famous precursors such as Meret Oppenheim, the practitioners of Pop Art and New Realism, and more recently Jeff Koons, her wholly singular oeuvre must be understood first and foremost from within.

Going back a little way in time to trace the history of her work, we arrive at 2008, when Kata Legrady made herself known with the emblematic series *Guns & Candies*. This already encapsulates in embryonic form all of its potential allure and appeal in terms of violent antagonism between two types of object that are poles apart. Here the artist found her own unique way of combining the machined metal of guns and brightly coloured, mouth-watering candies.

Whether monochromatic or multicoloured, her photographic compositions, objects and sculptures can initially appear glittering, playful and even bewitching until we are challenged and brought to a halt by their underlying violence, made all the more glacial by its always latent and symbolic nature. In actual fact, as the artist herself explains, she uses objects to compose the indirect portrait of a reality that is never illustrated or represented straight but always masked. It is in this interplay of allusions and implicit suggestions, in this system of revealing and concealing that the meaning and aims of her work entwine.

The first to see and collect her work were also struck by the sort of reserve and particular quality of silence that seem to surround each of her creations, inviting us to work out for ourselves the meaning of what is revealed in the form of an *evident enigma*.

Does this bring us back solely to the violence of the period, the deviation of our values and the general aestheticization that contaminates everything, including economic war or war pure and simple? Is it a biting criticism of the violence inherent in a society where guns are mass-produced like other articles of consumption? Are these images connected with a more personal and intimate part of the artist's lived experience and biography? Kata Legrady always shrewdly dodges this kind of question and asks us all to draw upon our own powers of elucidation, as she sees art as a matter of appropriating things – even at the risk of absurdity – rather than following banal forms of use. It is perhaps also for this reason that her art succeeds in reaching such different sections of the public.

We must not, however, let these joyous colours and apparent light-heartedness mislead us. What seems transparent is actually opaque and every part of light has a corresponding part of shadow. In this sense, Legrady recalls Warhol in her way of playing with the surface and immediacy of things and images. One thought or thing always covers another in her work: a mask covers another mask; banknotes cover revolvers or skulls; images cover objects. The artist has remained faithful to this practice in all the series that have followed *Guns & Candies*.

Let us now turn to the true heart of her art, namely drawing, which encapsulates and reflects her work as a whole in a certain sense.

Drawing performs a number of functions here, making it possible not only to give visual form to an initial idea that will serve as the starting point for a photograph or sculpture, but also to put a new slant on an already existing work. While certain drawings can almost be used as plans and technical specifications, others appear to constitute a kind of graphic report on the work itself, a *mise en abyme* of what the artist imagines, conceives and creates.

Architecture, portraiture and the visionary dimension: a different way of drawing corresponds to each of these three registers – three types of line and composition that each reflect a particular aspect of her artistic personality. The hand can flit around to capture a fleeting vision, firmly draw the rigorous plan of an object and delicately return to emphasize a contour or conjure up an already existing figure.

All these series of drawings ultimately constitute a kind of herbarium, an album where the principal "species" on which the artist works are methodically catalogued as well as the individual variations within each of them. On turning the pages, we thus see each of the key objects that

constitute the raw material of her work in quick succession: masks for disguise and gas masks, hand grenades, mines and guns, Colt revolvers and machine guns, gigantic multi-coloured bombs, Smarties, skulls, banknotes, rocking horses and saddles for real or imaginary rides, music boxes and a whole gallery of legendary figures from the worlds of Disney and super heroes.

In the era of complete digitization and on-screen pre-visualization, the artist deliberately opts for a manual form of image production, displaying equal fondness for paper and ink and for slate and coloured chalk.

Each series enables her to try out variations of scale and colour or different viewpoints on pieces of sculpture. As in her photographs, the objects drawn seem to float in mid-air. There is neither background nor context, simply the material of the support against which a generally central motif stands out. The object levitates and invites us to follow suit, prompting both reflection and reverie with the lightest of touches. Paradoxically enough, it is in immobility that it seems to attain its greatest speed and force of impact.

In actual fact, everything in Kata Legrady's art is born out of drawing, develops through drawing and ends in drawing: the initial spontaneous outflow and the methodical archive. Among the numerous precedents we find Vincent van Gogh, who included drawings of his paintings in the letters to his brother Theo, the meteorological notes and sketches of ongoing works in Pierre Bonnard's diaries, and Marcel Duchamp's *Boîte-en-valise* recapitulating the salient points of his creative activity on a smaller scale.

Funes, the leading character in one of the best-known short stories of Jorge Luis Borges, was endowed with a memory so perfect and infallible that words struck him as incapable of capturing the ever-changing diversity of reality: "He found it hard to understand not only that the generic symbol *dog* embraced so many dissimilar individuals of different shapes and sizes, but also why the dog seen from the side at 3.14 should be called the same thing as the dog seen from the front at 3.15".

In a certain sense, Kata Legrady's drawing echoes the language dreamed of by Funes, as each drawing becomes the unique name and memory of a particular aspect of one or another of her creations.

APPENDIX

Kata Legrady was born in Hungary. Youth champion in gymnastics, she also received a musical and aesthetic education. She studied at the Conservatory of Music in Pécs as lyric opera singer. In Budapest, she studied drama at Gor Nagy Maria Drama School and participated in different musical and film projects. For several years in Germany she taught piano and singing and conducted the Choir Sinfonia of Hanover. While living in Oxford, New York and Paris, she started to visit various artist's studios and made the acquaintance of Jacques Villeglé, Raymond Hains and Philippe Pasqua, among others. In 2004, she met Daniel Spoerri who became a friend and mentor of her artistic activities. Her public artistic life started in 2010. She now lives and works in Hanover, Paris and Budapest. Kata Legrady's works are regularly shown in main international art fairs, among which: Art Paris Art Fair 2010 to 2013, Grand Palais, Paris, in collaboration with Galerie Rabouan Moussion; Art HK, Hong Kong International Art Fair 2012, Hong Kong, in collaboration with Pékin Fine Arts; The Armory Show 2013, Piers 92 & 94, New York City, in collaboration with Pékin Fine Arts; Drawing Now 2013, Carrousel du Louvre, Paris, in collaboration with Galerie Rabouan Moussion; Art Basel Hong Kong 2013, Hong Kong, in collaboration with Pékin Fine Arts.

Selected exhibitions

2010
Bombs and Candies, Galerie Rabouan Moussion, Paris (solo exhibition).

2011
Kata Legrady, Galerie Pari Nadimi, Toronto (solo exhibition).
Masks and Guns, Galerie Rabouan Moussion, Paris (solo exhibition).
Le Cabinet de Curiosités de Thomas Erber, Browns, London.
Kata Legrady, Fondazione Mudima, Milan (solo exhibition).

2012
Bombs and Candies – dulce et decorum, Denkerei Bazon Brock, Berlin (solo exhibition).
Le Luxe, mode d'emploi, Passage de Retz, Paris.
Le Cabinet de Curiosités de Thomas Eber, Andreas Murkudis, Berlin.
Le Cabinet de Curiosités de Thomas Erber, special edition, BMW George V, Paris.

2013
Bombs and Candies, Kulturstiftung Marienmünster, Marienmünster (solo exhibition).
Hybride 2, Ancien hôpital général, Douai.
Kata Legrady & Wang Luyan, Hong Kong Arts Centre, Hong Kong.

2014
Caravana Negra, La Boca, Buenos Aires.
Kata Legrady, ZKM | Zentrum für Kunst und Medientechnologie Karlsruhe (solo exhibition).
Kata Legrady, Käthe-Kollwitz-Museum, Berlin.

Selected literature

Bombs and Candies (Milan: Skira editore, 2011).
Kata Legrady (Milan: Skira editore, 2013).
Kata Legrady (Berlin: Distanz Verlag, 2013).
Once upon a time... Kata Legrady Graphic Works (Milan: Skira editore, 2014).

List of Works

Masks & Guns

9
Catwoman (yellow), 2013
Coloured pencil and pencil on paper
21 x 14.7 cm

10
Catwoman (pink), 2013
Coloured pencil and pencil on paper
21 x 14.7 cm

10
Catwoman (blue), 2013
Coloured pencil and pencil on paper
21 x 14.7 cm

11
Catwoman "US Dollar" (green), 2013
Coloured pencil and pencil on paper
21 x 14.7 cm

12
Government "Saddle" (blue I), 2013
Coloured pencil and pencil on paper
21 x 14.7 cm

13
Government "Saddle" (blue II), 2013
Coloured pencil and pencil on paper
21 x 14.7 cm

14
Government "Saddle" (white II), 2013
Coloured pencil and pencil on paper
21 x 14.7 cm

14
Government "Saddle" (white I), 2013
Coloured pencil and pencil on paper
21 x 14.7 cm

15
Government "Saddle" (pink II), 2013
Coloured pencil and pencil on paper
21 x 14.7 cm

15
Government "Saddle" (pink I), 2013
Coloured pencil and pencil on paper
21 x 14.7 cm

15
Government "Saddle" (yellow II), 2013
Coloured pencil and pencil on paper
21 x 14.7 cm

16
Government "Saddle" (yellow I), 2013
Coloured pencil and pencil on paper
21 x 14.7 cm

16
Government "Saddle" (brown II), 2013
Coloured pencil and pencil on paper
21 x 14.7 cm

17
Government "Saddle" (brown I), 2013
Coloured pencil and pencil on paper
21 x 14.7 cm

Strange Fruits

21
Pea Pod, 2011
Ink on paper
29.7 x 42 cm

22
Nut, 2011
Ink on paper
29.7 x 42 cm

23
Dandelion, 2011
Ink on paper
29.7 x 42 cm

24–25
Asparagus, 2011
Ink on paper
29.7 x 42 cm

Sweet Weapons

29
Child Soldier & Kalashnikov, 2007
Colour print and pencil on paper
58.2 x 45 cm (framed)

30
Kalashnikov (multicolor), 2007
Felt pen on photograph
30 x 61.2 cm

31
Kalashnikov (multicolor), 2007
Felt pen on photograph
30 x 61.2 cm

32
Machine Gun, 2007
Pencil on paper
21 x 29.5 cm

33
Short Gun, 2007
Pencil on paper
21 x 29.5 cm

34
Kalashnikov, 2007
Pencil on paper
21 x 29.5 cm

35
Government, 2007
Pencil on paper
21 x 29.5 cm

36
Machine Gun, 2007
Pencil on paper
57.5 x 77 cm

37
Government, 2007
Pencil on paper
57.2 x 77 cm

38
Kalashnikov & Long Pistol, 2007
Pencil on paper
48 x 34.8 cm (framed)

39
Little Boy, 2007
Technical drawing
85.6 x 61 cm (framed)

40
Kalashnikovs & Pineapple, 2008
Pencil on paper
35.1 x 57.2 cm (framed)

41
Bomb, 2009
Drawing on canvas
125.5 x 181 cm

Music Box

45
Mickey & Minnie, 2013
Chalk on chalkboard
200 x 150 cm

46
Mickey & Minnie I, 2012
Chalk on chalkboard
60 x 45 cm

47
Mickey & Minnie II, 2012
Chalk on chalkboard
60 x 45 cm

48
Mickey & Minnie III, 2012
Chalk on chalkboard
60 x 45 cm

49
Mickey & Minnie IV, 2012
Chalk on chalkboard
60 x 45 cm

50
Mickey & Minnie V, 2012
Chalk on chalkboard
60 x 45 cm

51
Mickey & Minnie VI, 2012
Chalk on chalkboard
60 x 45 cm

52
Mickey & Minnie VII, 2012
Chalk on chalkboard
60 x 45 cm

53
Mickey & Minnie VIII, 2012
Chalk on chalkboard
60 x 45 cm

54
Mickey & Minnie IX, 2012
Chalk on chalkboard
60 x 45 cm

55
Mickey & Minnie X, 2012
Chalk on chalkboard
60 x 45 cm

Blackboards

59
Government "Saddle", 2013
(right board of triptych)
Chalk on chalkboard
200 x 150 cm

60
Government (pink), 2013
Chalk on chalkboard
50 x 60 cm

61
Pineapple (blue), 2013
Chalk on chalkboard
60 x 50 cm

62
Pineapple (multicolor), 2013
Chalk on chalkboard
60 x 50 cm

63
Government "Saddle", 2013
(left board of triptych)
Chalk on chalkboard
200 x 150 cm

64
Pineapple "Flower" (multicolor), 2013
Chalk on chalkboard
60 x 50 cm

65
Pineapple (multicolor), 2013
Chalk on chalkboard
60 x 50 cm

66
Government (yellow), 2013
Chalk on chalkboard
50 x 60 cm

66
Government (green), 2013
Chalk on chalkboard
50 x 60 cm

67
Government "US Dollar", 2012
Chalk on chalkboard
45 x 60 cm

68
Blackbird "US Dollar", 2012
Chalk on chalkboard
60 x 45 cm

69
Bullet "US Dollar", 2012
Chalk on chalkboard
60 x 45 cm

70
Bullet "Stars and Stripes", 2012
Chalk on chalkboard
60 x 45 cm

70
Bullet "Flower" (multicolor), 2012
Chalk on chalkboard
60 x 45 cm

71
Skull "Flower", 2012
Chalk on chalkboard
60 x 45 cm

72
Skull "Comic", 2012
Chalk on chalkboard
60 x 45 cm

73
Hero "Spiderman", 2012
Chalk on chalkboard
60 x 45 cm

74
Hero "Spiderman II", 2012
Chalk on chalkboard
60 x 45 cm

75
Hero "Iron Man", 2012
Chalk on chalkboard
60 x 45 cm

76
Hero "Wolverine", 2012
Chalk on chalkboard
60 x 45 cm

77
Hero "Captain America", 2012
Chalk on chalkboard
60 x 45 cm

78
Catwoman, 2012
Chalk on chalkboard
60 x 45 cm

79
Hero "Thor", 2012
Chalk on chalkboard
60 x 45 cm

80
Disney "Daisy", 2012
Chalk on chalkboard
60 x 45 cm

80
Disney "Goofy", 2012
Chalk on chalkboard
60 x 45 cm

81
Disney "Dagobert", 2012
Chalk on chalkboard
60 x 45 cm

82
Disney "Mickey", 2012
Chalk on chalkboard
60 x 45 cm

83
Disney "Mickey II", 2012
Chalk on chalkboard
60 x 45 cm

84
Mickey, Pearl Harbor 8, 2012
Chalk on chalkboard
60 x 45 cm

84
Mickey, Pearl Harbor 7, 2012
Chalk on chalkboard
60 x 45 cm

84
Mickey, Pearl Harbor 9, 2012
Chalk on chalkboard
60 x 45 cm

85
Disney "Minnie", 2012
Chalk on chalkboard
60 x 45 cm

86
Cheval à bascule, 2012
Chalk on chalkboard
45 x 60 cm

87
Snow Dome "Teddy", 2013
Chalk on chalkboard
200 x 150 cm

88–89
Little Boy I, 2012
Chalk on chalkboard
45 x 60 cm

90
Little Boy III, 2012
Chalk on chalkboard
45 x 60 cm

90
Little Boy II, 2012
Chalk on chalkboard
45 x 60 cm

90
Little Boy IV, 2012
Chalk on chalkboard
45 x 60 cm

91
Little Boy V, 2012
Chalk on chalkboard
60 x 45 cm

Drafts & Shapes

95
*Sketch for "Pink Bomb" and
"Cheval à bascule"*, 2009
Coloured pencil and pencil on paper
21.9 x 13.6 cm

96
Sketch for "Skull 'Flower'", 2011
Coloured pencil and pen on paper
21 x 29.4 cm

97
*Sketch for Sculpture "Bullets 'Flower'
on Music Box"*, 2011
Coloured pencil and pencil on paper
21 x 29.4 cm

98
Sketch for "Skulls on Music Box", 2011
Coloured pencil and pen on paper
21 x 29.4 cm

99
Sketch for "Bananas on Music Box", 2011
Coloured pencil and pen on paper
21 x 29.4 cm

100
Sketch for "Banana Swing Music Box", 2011
Coloured pencil and pen on paper
21 x 29.4 cm

101
Sketch for "Banana-Bomb Music Box", 2011
Coloured pencil and pen on paper
21 x 29.4 cm

102
Sketch for Sculpture "Banana Swing", 2011
Coloured pencil and pen on paper
21 x 29.4 cm

103
Sketch for "Banana Swing", 2011
Coloured pencil and pen on paper
21 x 29.4 cm

105
Sketch for Sculpture "Warrior", 2010
Pen on paper
10.5 x 14.7 cm

105
*Sketch for Sculpture
"Warrior Man and Woman"*, 2010
Pen on paper
10.5 x 12.6 cm

106
Sketch for Sculpture "Flying Horses", 2010
Pen on paper
21.9 x 15.6 cm

107
Sketch for Sculpture "Rearing Horses", 2010
Pen on paper
15.6 x 21.9 cm

Pocket-size Drawings

111
Denix Remington, 2011
Coloured pencil and pencil on paper
21 x 14.8 cm

112
Butterfly-Gun (red), 2013
Coloured pencil and pencil on paper
21 x 14.8 cm

112
Butterfly-Gun (blue), 2013
Coloured pencil and pencil on paper
21 x 14.8 cm

113
Butterfly-Gun (pink), 2013
Coloured pencil and pencil on paper
21 x 14.8 cm

114
Butterfly-Government (blue), 2013
Coloured pencil and pencil on paper
21 x 14.8 cm

114
Butterfly-Government (red), 2013
Coloured pencil and pencil on paper
21 x 14.8 cm

115
Butterfly-Government (multicolor), 2013
Coloured pencil and pencil on paper
21 x 14.8 cm

116
Butterfly-Government "US Dollar", 2013
Coloured pencil and pencil on paper
21 x 14.8 cm

116
Butterfly-Government "US Dollar" (pink), 2013
Coloured pencil and pencil on paper
21 x 14.8 cm

116
Butterfly-Government "US Dollar" (blue), 2013
Coloured pencil and pencil on paper
21 x 14.8 cm

117
Butterfly "US Dollar" I, 2013
Coloured pencil and pencil on paper
21 x 14.8 cm

117
Butterfly "US Dollar" II, 2013
Coloured pencil and pencil on paper
21 x 14.8 cm

117
Butterfly "US Dollar" III, 2013
Coloured pencil and pencil on paper
14 x 19.7 cm

118
Gasmask 4 (blue), 2011
Coloured pencil and pencil on paper
21 x 14.8 cm

118
Mine (multicolor), 2011
Coloured pencil and pencil on paper
21 x 14.8 cm

118
Pineapple (multicolor), 2011
Coloured pencil and pencil on paper
21 x 14.8 cm

119
Bullet (multicolor), 2011
Coloured pencil and pencil on paper
21 x 14.8 cm

119
Bullet (pink), 2011
Coloured pencil and pencil on paper
21 x 14.8 cm

120
Pineapple "Flower", 2011
Coloured pencil and pencil on paper
21 x 14.8 cm

120
Bullet "Flower" (multicolor), 2012
Coloured pencil and pencil on paper
21 x 14.8 cm

121
Skull "Flower", 2011
Coloured pencil and pencil on paper
21 x 14.8 cm

121
Government "Flower" (multicolor), 2013
Coloured pencil and pencil on paper
21 x 14.8 cm

122
Pineapple "US Dollar", 2013
Coloured pencil and pencil on paper
21 x 14.8 cm

123
Bullet "US Dollar", 2011
Coloured pencil and pencil on paper
21 x 14.8 cm

123
Government "US Dollar", 2011
Coloured pencil and pencil on paper
21 x 14.8 cm

123
Blackbird "US Dollar" (pink), 2013
Coloured pencil and pencil on paper
21 x 14.8 cm

124
Skull "US Dollar", 2013
Coloured pencil and pencil on paper
21 x 14.8 cm

125
Skull "Comic" I, 2011
Coloured pencil and pencil on paper
21 x 14.8 cm

125
Skull "Comic" II, 2011
Coloured pencil and pencil on paper
21 x 14.8 cm

125
Skull "Comic" III, 2011
Coloured pencil and pencil on paper
21 x 14.8 cm

126
Disney "Dagobert", 2011
Coloured pencil and pencil on paper
21 x 14.8 cm

126
Disney "Daisy", 2011
Coloured pencil and pencil on paper
21 x 14.8 cm

127
Hero "Captain America", 2011
Coloured pencil and pencil on paper
21 x 14.8 cm

127
Hero "Spiderman", 2011
Coloured pencil and pencil on paper
21 x 14.8 cm

127
Catwoman, 2011
Coloured pencil and pencil on paper
21 x 14.8 cm

128
Cheval à bascule I, 2011
Coloured pencil and pencil on paper
21 x 14.8 cm

128
Cheval à bascule II, 2011
Coloured pencil and pencil on paper
21 x 14.8 cm

128
Cheval à bascule, 2013
Pencil on paper
14 x 19.7 cm

129
Government Balançoire, 2011
Coloured pencil and pencil on paper
21 x 14.8 cm

129
Government Balançoire, 2011
Coloured pencil and pencil on paper
21 x 14.8 cm

Skulls & Banknotes

133
Skull "US Dollar" (blue), 2012
Acrylic on paper
40.7 x 28.7 cm

135
Skull "US Dollar" (pink), 2012
Acrylic on paper
40.7 x 28.7 cm

136
Skull "US Dollar" (green), 2012
Acrylic on paper
40.7 x 28.7 cm

137
Skull "US Dollar" (yellow), 2012
Acrylic on paper
40.7 x 28.7 cm

138
Skull "Splash" (pink), 2012
Watercolour on paper
40.7 x 28.7 cm

138
Skull "Splash" (yellow), 2012
Watercolour on paper
40.7 x 28.7 cm

139
Skull "Splash" (blue), 2012
Watercolour on paper
40.7 x 28.7 cm

139
Skull "Splash" (green), 2012
Watercolour on paper
40.7 x 28.7 cm